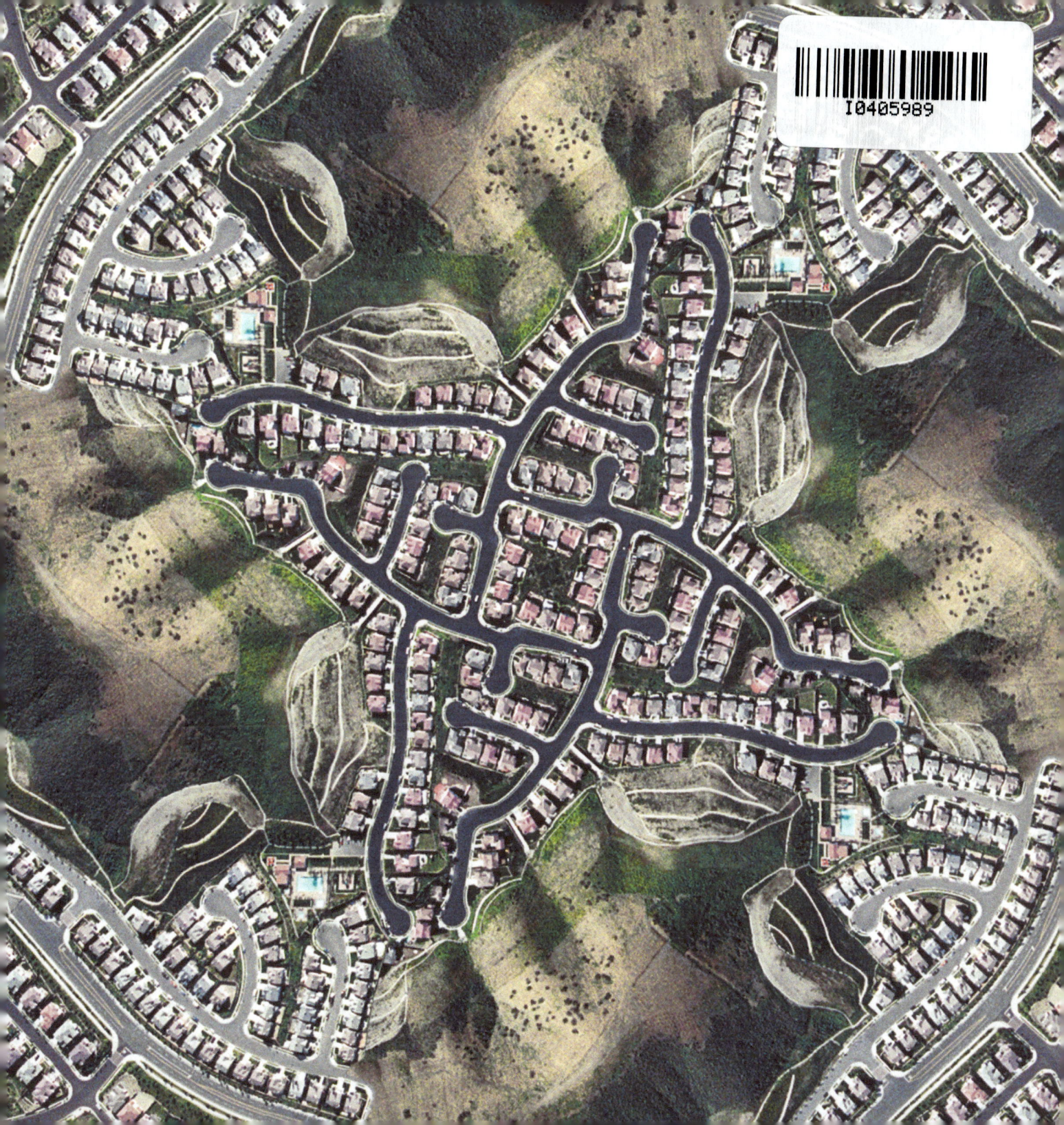

THE GALLERY@CALIT2
EXHIBITION CATALOG N°4

SCALABLE CITY

OCTOBER 23, 2008 TO
DECEMBER 15, 2008

Copyright 2008 by the gallery@calit2

Published by the gallery@calit2

University of California, San Diego
9500 Gilman Drive
La Jolla, CA, 92093-0436

ISBN 978-0-578-00316-0

CONTENTS

04 Introduction to Scalable City, by Sheldon Brown

08 Interview with Sheldon Brown, by Eduardo Navas

22 Essay: Cutting Across Somewhere Between in the Scalable City, by Bruce Sterling

30 Essay: A Scalable Me for Scalable Times, by Geoff Ryman

36 Extract: The Gold Coast, By Kim Stanley Robinson

44 Short story: Care, By Geoff Ryman and Sheldon Brown

54 Artist Biography

56 Acknowledgments

Unattributed text by Eduardo Navas

Image on page 1: Scalable City - Print #2

INTRODUCTION
SCALABLE CITY

BY SHELDON BROWN

The "Scalable City" is an ongoing art work that extends to various media, including gaming, immersive installations, sculptures and digital prints. Its central piece is a computer game involving users, data and algorithms as applied to urban development. As our world becomes increasingly characterized by this equation, we find ourselves inhabiting the artifacts of these relationships. Scalable City places responsibility for this on each of its users; their activities are simultaneously constructive and destructive. This work poetically draws analogies through mis-application of computational processes to design decisions and how development in general can produce unintended effects after much iteration.

This is experienced by users as their movements shape the interactions of major components of the world. Within the Scalable City are five major components: landscape, roads, lots, architecture and vehicles. Each is created by a process where real-world data are subjected to algorithmic transformations before being redeployed as elements of a new urban condition of software input/output.

Each user controls a vortex of automobiles, which continually spew copies of themselves into the atmosphere. As this vortex moves through the landscape, it causes roads to "grow". Scattered throughout the landscape are architectural fragments. This junk is flung into the air by the car tornados and the pieces then try to reform back into houses. As they do so, they produce shanty-like facsimiles of their original form, which are scattered again into the landscape when another car vortex passes by.

All processes encode their results with artifacts that express their virtues and shortcomings. As culture continues its transition from analog to digital forms, we produce tensions between speculation and anxiety. Scalable City attenuates the experience of our presence in the world as a process of transformation, promoting awareness of how tools and attitudes can become systems that perpetuate their own logic rather than that of long-term benefit.

In Scalable City, the aesthetic gestures embody the tension between exuberance and foreboding, neither embracing nor rejecting an algorithmic world view, but inspiring its expressivity while cautioning of its own internal logics becoming the dominant determinant of its outcomes.

Support for the development of Scalable City comes from IBM, Intel, Sun Microsystems, Vicon, High Moon Studios, the UC Discovery Grant program, UCSD's Center for Research in Computing and the Arts (CRCA), as well as the UCSD division of the California Institute for Telecommunications and Information Technology (Calit2), whose gallery@calit2 in Atkinson Hall is the venue for the current exhibit.

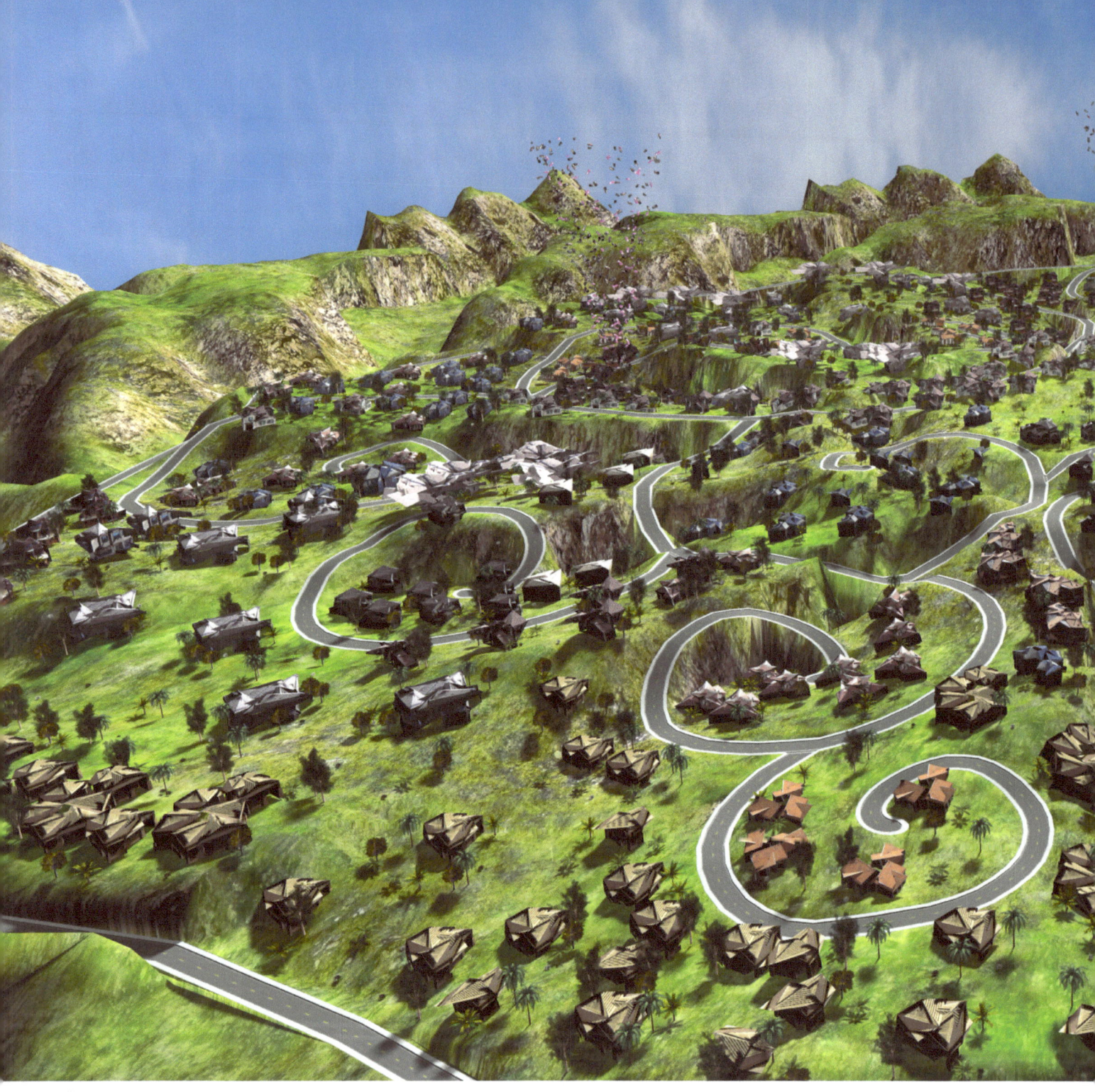

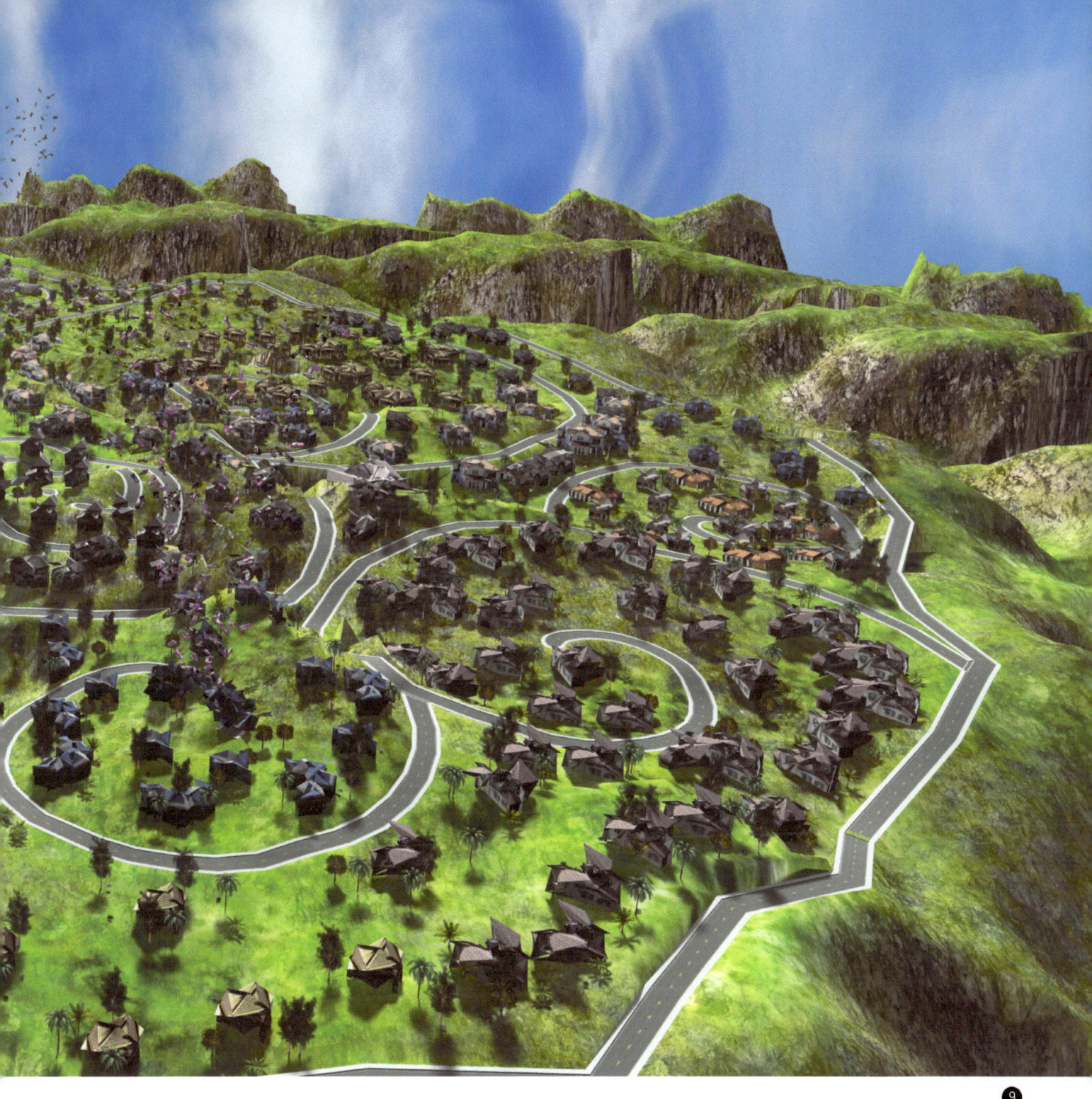

INTERVIEW
SHELDON BROWN

BY EDUARDO NAVAS

Sheldon Brown is an artist who works in new forms of culture that arise out of developments in computing technology. He is Director of the Center for Research in Computing and the Arts (CRCA) at UC San Diego, where he is a Professor of Visual Arts and an academic participant in the California Institute for Telecommunications and Information Technology (Calit2). During his early career, Brown experimented with emerging technologies to develop works that explore the possible meaning of "virtual reality." His installations were often designed for immersive audience participation. Many of these works have been developed for the gallery, such as "MetaStasis" (1990), an art installation consisting of a room that visitors enter to experience what appears to be, as Brown himself has called it, a "zoetrope of TV images." Brown took his interest in mediated reality to the public sphere in installations such as "Video Wind Chimes" (1994), which projects broadcast TV images on the street sidewalk – images selected according to how the wind blows. In both of these projects, as well as many others, Brown emphasizes how metaphysical experience is contingent upon our increasing dependency in immersive media of all forms. Brown's longstanding interest in mediation is further explored in "Scalable City." In the following interview, the artist reflects on how Scalable City connects his interests in emerging technologies as well as longstanding traditions of art practice.

[Eduardo Navas] Unlike many artists who claim to be interested primarily in expressing their ideas and not being bound to a specific medium, you have chosen to focus on the development of art that is involved with computing technology. Having said this, the computer makes possible metamedia – meaning it simulates other media, and in this sense it allows artists to focus on idea development. It appears, then, that you share the interest of exploring ideas in the tradition of modern art practice with artists who might play down their preference for a particular medium. With this in mind, could you reflect on the shifts that art practice may be taking based on the increasing role of computers in all aspects of our lives? How do you see your art practice in relation to previous practices which may have downplayed their preference for a particular medium?

[Sheldon Brown] It seems you attribute conflicting claims for my relationship to "medium", but I don't see computing as a medium in the 20th century sense. Probably even the idea of it as a meta-medium does not

capture its character. It may be more useful to think about computing as creating certain cultural conditions, and I'm doing work which utilizes and responds to those conditions. It might then be more like the interest in speed as a condition for the futurists, but I wouldn't want to make too much of any analogies to previous art movements and their concerns. The impact of computing on culture comes after the modernist, conceptualist and post-modernist engagements, and just as I have called it a meta-medium, I could also call it a meta-ism – it is able to simulate any and all of these previous attitudes. Not that my interests in this begin and end at simulation of previous forms; this is but one of the gestures possible in this condition, but when it performs any of these simulations, they become rapidly engaged in a new dynamic which doesn't stop at borders of previous operations.

[EN] The strength of computing appears to be the ability to simulate, hence your calling it a meta-medium or meta-ism sounds reasonable. The term meta-media as we know was coined by Marshall McLuhan, but the principles of simulation were conceptualized by Alay Kay when he proposed the Dynabook, which is essentially the computer laptop today. Would you say that the tendentious aesthetic of simulation is currently at play because the computer was conceptualized deliberately as a meta-medium by individuals who were influenced by the ideas of McLuhan and Kay? What does this tendency mean for the way we view reality once computing becomes the basis for media in general?

[SB] Simulation is a very core idea in computing – but not the only one involved. I would peel back the references you cite a bit further to look at the concept of the universal Turing machine as key to the nature of computing – a machine that is able to simulate other Turing machines. However, the simulation is just the starting point. The quantitative nature of computing is crucial. It may be able to simulate a logical operation, but the ability of doing a few billion of these a second creates a new phenomenon. The multitudinous simulations of previous forms in previously improbable combinations combine to create new entities. Therefore, it simply isn't enough to look at the outcomes of digital culture with the analytical frameworks of previous eras and think that computing is just simulating or replaying those forms. Realizing that this quantitative property of computing is crucial to its nature, it is important to note that this property is rapidly changing. Comput-

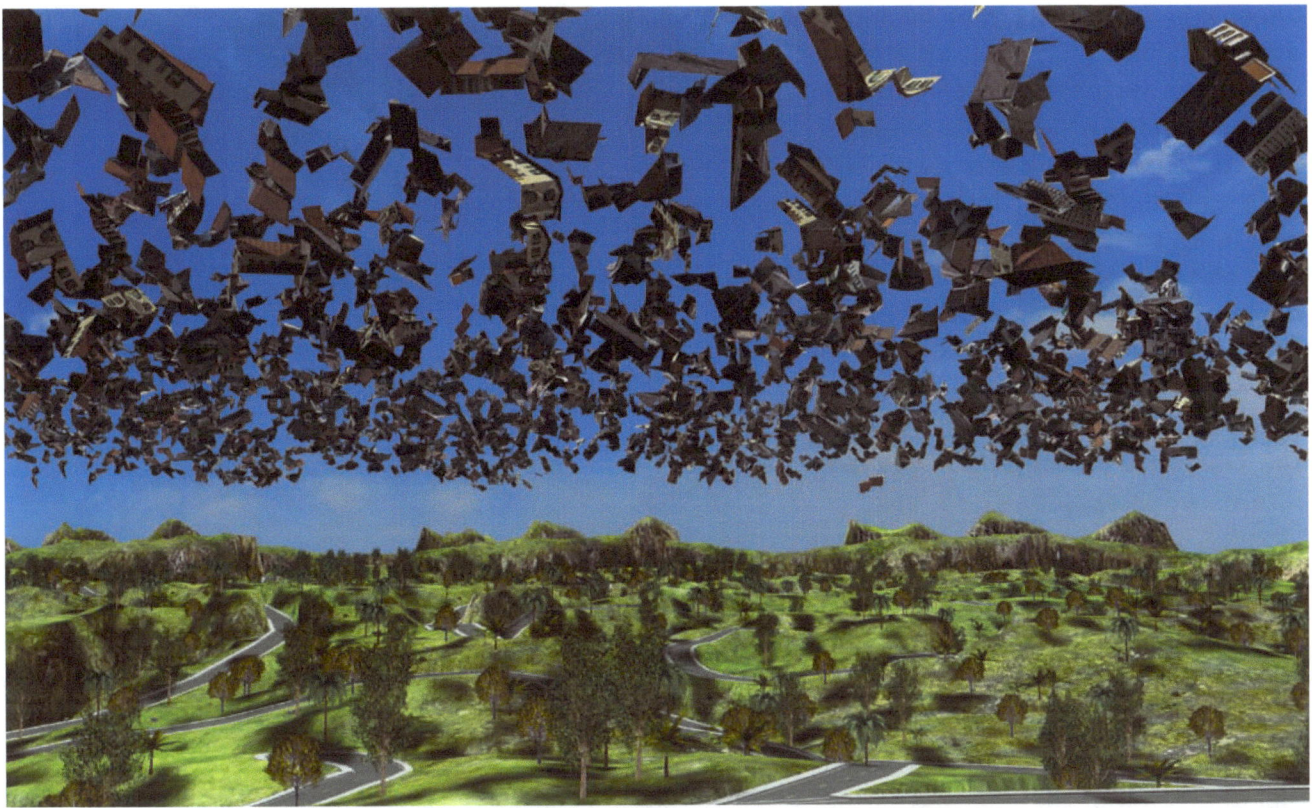

ing today is not the computing we will know tomorrow, and there is no foreseeable endpoint for when it will cease its Moore's-law redoubling. As it continues this development, more aspects of reality become a part of its operations. So certain concepts that have efficacy in computing become applied across cultural domains that previously hadn't been considered as computable, and then they become translatable and accessible to the broad realm of the computational. Will this distort our views of reality? Of course! The invention of perspective has distorted our conception of space. Every tool has both intended and unintended effects. These unintended, ancillary artifacts are places that are very useful in seeing the juxtaposition of intent and outcome.

[EN] You argue that film language has been a defining element that has shaped reality. In your text "4K Fidelity in the Scalable City," you allude to a new stage of simulation that is arising, which relies in part on 4K technology – an image technology that describes the spatial resolution of the image, ~4,000 x 2,000 pixels. The result is a highly detailed image that supersedes anything seen before. Yet, this is happening in a time when we also rely on low-resolution im-

STILL FROM THE SCALABLE CITY NEW TRAILER

ages, which are likely to be more popular since they are privileged by mobile devices. How do you see 4K influencing other areas of visual culture beyond the big screen? Will it be a medium of privilege, like film was in its early days, or will it somehow become part of popularly used devices? Will the Scalable City also be accessible in other forms, or do you see it primarily moving towards high-resolution technology due to the concepts of immersion you are interested in exploring?

[SB] The 4K format is a means to crack the cinematic nut, to turn it into a digital medium. A fully digital cinema becomes a territory for the rampant activities that we've seen occur when other mediums become digital – think of the changes to the music industry. While the digitization of cinema has been happening in many facets, the movie theater has maintained a constant structure fronting the movie industry with its fairly stable forms of production and dissemination. It bifurcates cinema culture into professional and amateur realms: the professional engages digital production means (from overt special effects to simply a part of the production pipeline of color correction, lighting adjustments, sound design, and removal of wires, pimples, and wrinkles), and the amateur exploits

distribution forms (YouTube, etc.).

The final format of this new digital cinema will not be 4K. This is simply the first movie theater scale digital form that has visual qualities that are desirable in comparison to film. Once the transition occurs to digital cinema presentation and dissemination, the formats of presentation are likely to change and diversify rapidly. Developing outcomes that can migrate across a multiplicity of forms, even taking advantage of different affordances that a form may have, will be more and more the case. Scalable City alludes to this in its operations as a series of movies, as an installation, as prints, as objects, and soon as a downloadable online game. Within each of these, there are variations – the interactive installation is configured differently for each venue – but at each venue and for each form, I am bringing forward particular qualities of the work.

[EN] You are able to walk a fine line between art and technology. As you explain, much of your funding comes from institutions that support computer science. How do you see the relationship of art, science and technology today, especially when much funding comes from corporations ultimately interested in the bottom line? And how does

this affect the type of criticism that has traditionally been part of the fine arts? Is the arts' critical methodology being redefined?

[SB] The relationship of how work is supported to what it addresses seems to have fallen out of the critical banter in the last couple of decades (post-1980), with the gallery system and the relationship to museums and collectors less critically examined as a part of how artwork is validated. I think the economies of production should be considered as a part of the reading of a work. It doesn't entirely constrain the work to these systems. We are able to look at Michelangelo's efforts and not only see them as di Medici decorations, but by having some analysis of this, we can understand some things about intent and outcome. In my work, I'm continually looking at what we are about to be able to see and do through the developments of our technologies of knowledge, vision and representation. Pushing these forward requires that I develop new approaches for the advances that come from computing. This builds knowledge that extends beyond the confines of this particular artwork at this time. I hope it can help make these technologies more effective for seeing further and knowing more.

"IT SIMPLY ISN'T ENOUGH TO LOOK AT THE OUTCOMES OF DIGITAL CULTURE WITH THE ANALYTICAL FRAMEWORKS OF PREVIOUS ERAS AND THINK THAT COMPUTING IS JUST SIMULATING OR REPLAYING THOSE FORMS. COMPUTING TODAY IS NOT THE COMPUTING WE WILL KNOW TOMORROW, AND THERE IS NO FORESEEABLE ENDPOINT FOR WHEN IT WILL CEASE ITS MOORE'S-LAW REDOUBLING. AS IT CONTINUES THIS DEVELOPMENT, MORE ASPECTS OF REALITY BECOME A PART OF ITS OPERATIONS. SO CERTAIN CONCEPTS THAT HAVE EFFICACY IN COMPUTING BECOME APPLIED ACROSS CULTURAL DOMAINS THAT PREVIOUSLY HADN'T BEEN CONSIDERED AS COMPUTABLE, AND THEN THEY BECOME TRANSLATABLE AND ACCESSIBLE TO THE BROAD REALM OF THE COMPUTATIONAL." - SHELDON BROWN

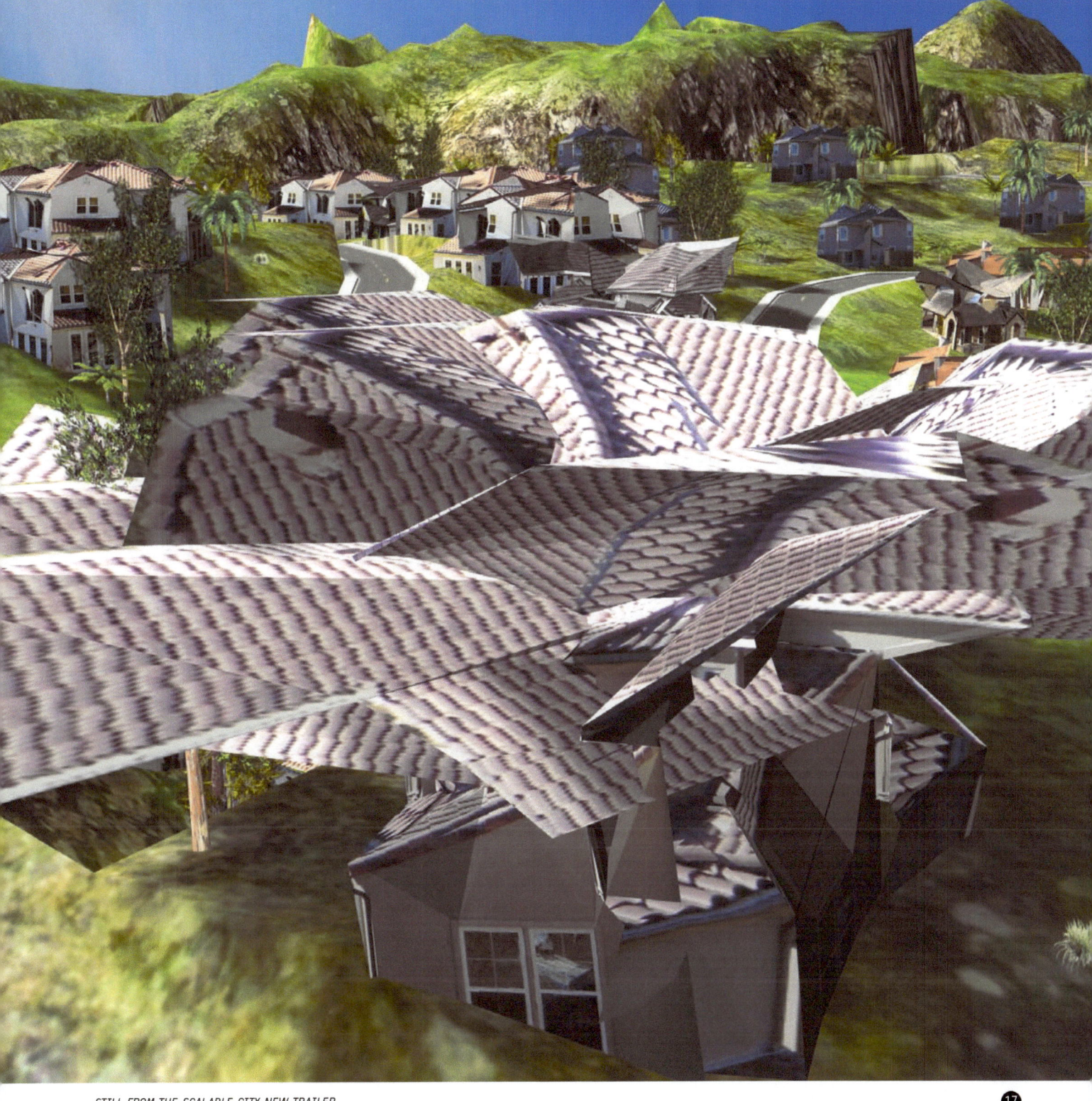

STILL FROM THE SCALABLE CITY NEW TRAILER

[EN] One of the challenges that appears to confront your art practice is that you are often dealing with subject matter that is not popularly recognizable, or even common within art circles. As we know, artists today tend to work mainly as commentators: they take material from culture and spin it in ways that invite viewers to reconsider how such elements are taken for granted or promoted by the media. In your situation, do you find that some explanation or contextualization is at times necessary for the wider art circle to better understand your work due to the specificity of the technology? Would you say that this is a recurring tendency that has kept artists invested in emerging media technologies from showing in certain major art venues?

[SB] You might be right in some of your assessments, but nevertheless, I would have to argue with some of your assertions such as "subject matter that is not popularly recognizable.". First of all, if you look at the visual elements of Scalable City, it consists of landscapes, automobiles and houses. I think those have popular recognizability. That they are visualized via techniques that forefront the artifacts of their representational systems – computer vision capture, polygonal forms, satellite imagery – are also commonly encountered artifacts of the contemporary visual world. What is probably less common is using the artifacts of these representations as a meaningful gesture in digital technology. Much of the way that digital forms are celebrated in popular media is for their disappearance. In cinema, it makes the unreal look real, but I think the relationship to reality and its representations is a much more complicated and interesting territory.

However, these works have a pretty high indulgence in these visual forms, which combine them in ways that are fairly overt. (Tornados of cars? Skyscrapers made of suburban house pieces? What's unfamiliar here?)

In this case, I think the multiple forms of the work provide an intra-commentary that is useful in reading the work. The cinematic works benefit the game works, which in turn illuminate the sculptural pieces. I do think that there is something in the operationality of these works (and others like them) that is an impediment for some to be able to really see them. The ability to consider is really important. The need to operate can interfere with that. A reader of these types of works sometimes needs to operate them, and then consider them. For some, that just seems like too much.

"MUCH OF THE WAY THAT DIGITAL FORMS ARE CELEBRATED IN POPULAR MEDIA IS FOR THEIR DISAPPEARANCE. IN CINEMA, IT MAKES THE UNREAL LOOK REAL, BUT I THINK THE RELATIONSHIP TO REALITY AND ITS REPRESENTATIONS IS A MUCH MORE COMPLICATED AND INTERESTING TERRITORY." - SHELDON BROWN

[EN] Golan Levin (and I think he would not mind that I say this) often refers to a "new media ghetto", meaning that due to the specifics of work like yours only so many venues can support it. Do you think we will move beyond this stage? And if so, how?

[SB] Maybe it is okay to be in this state. In the late 90's a bunch of institutions jumped on a new media bandwagon and launched a bunch of websites that seemed to be their response to the situation. This was mostly uninteresting, but did stimulate a rush toward this as a normalizing mode of new media art activity. For me, exhibiting is another part of the working process of creating a project. I enjoy showing in unusual and diverse venues. On occasion, new media art forums are of interest, as well as the more regular art world, but I also find that engaging in deep technology venues (Supercomputing conferences, SIGGRAPH, etc.), or architecture exhibitions, or science museums, can provide a contextuality that is not unlike creating public art. By this, I mean that each of these forums has a set of conversations that are ongoing, I enter into these knowing something of them, and through my work, I try and steer those conversations to some new territory. In the process, I gain a tremendous amount

by how the work is received, and the future directions that I will pursue.

But the slightly disengaged art world relationship to this field is ultimately an unfortunate situation. In the 20th century, the art world developed as our domain of cultural research. This research is not about material forms and techniques, but about how meaning operates in the created world around us (forms and techniques play a role in this). As our culture is undergoing a radical restructuring that is reflected and provoked by the transformation of many of its forms to computed entities, art is one of the domains that is working with the conundrums and possibilities of this moment. If the issues that new media arts are engaging are not part of a rigorous discourse, they become insular. If the art world ignores the field, it becomes irrelevant. That is the most caricatured description of the situation; it isn't that bleak, but it warrants ongoing address.

[EN] In your multifaceted project "Scalable City" you combine various forms of art production from prints to sculptures, implicitly leaning towards video gaming as a pivot in cultural production. To contextualize your practice in relation to these various forms of expression, you have developed the term "troiage aesthetics," which you argue is intimately bound to the development of computing, and is relevant to painting and literature. You explain that troiage aesthetics is defined by the acts of doing, seeing and thinking. What stands out in your theoretical description is that "troiage" emphasizes three-dimensionality, specific to computing media, and is dependent on reactive interaction by the viewer. Could you explain how you see immersive technology of this type redefining reception and interactivity? Particularly when you argue that all methods of sculptural reception are interactive, and you explain that the video game ruptures the previously established interactive paradigm? In this sense, is the Scalable City exploring a possible format that started with film, and may be moving to a paradigm in which the viewer will be expected not only to interact by perceiving, but also to react by performing an action?

[SB] Let me start by stating that my first interest in interactivity is that it provides a method to complicate the image plane, or the temporal image plane (provided by cinema). It is interactivity that spatializes this frame. This provides for a cu-

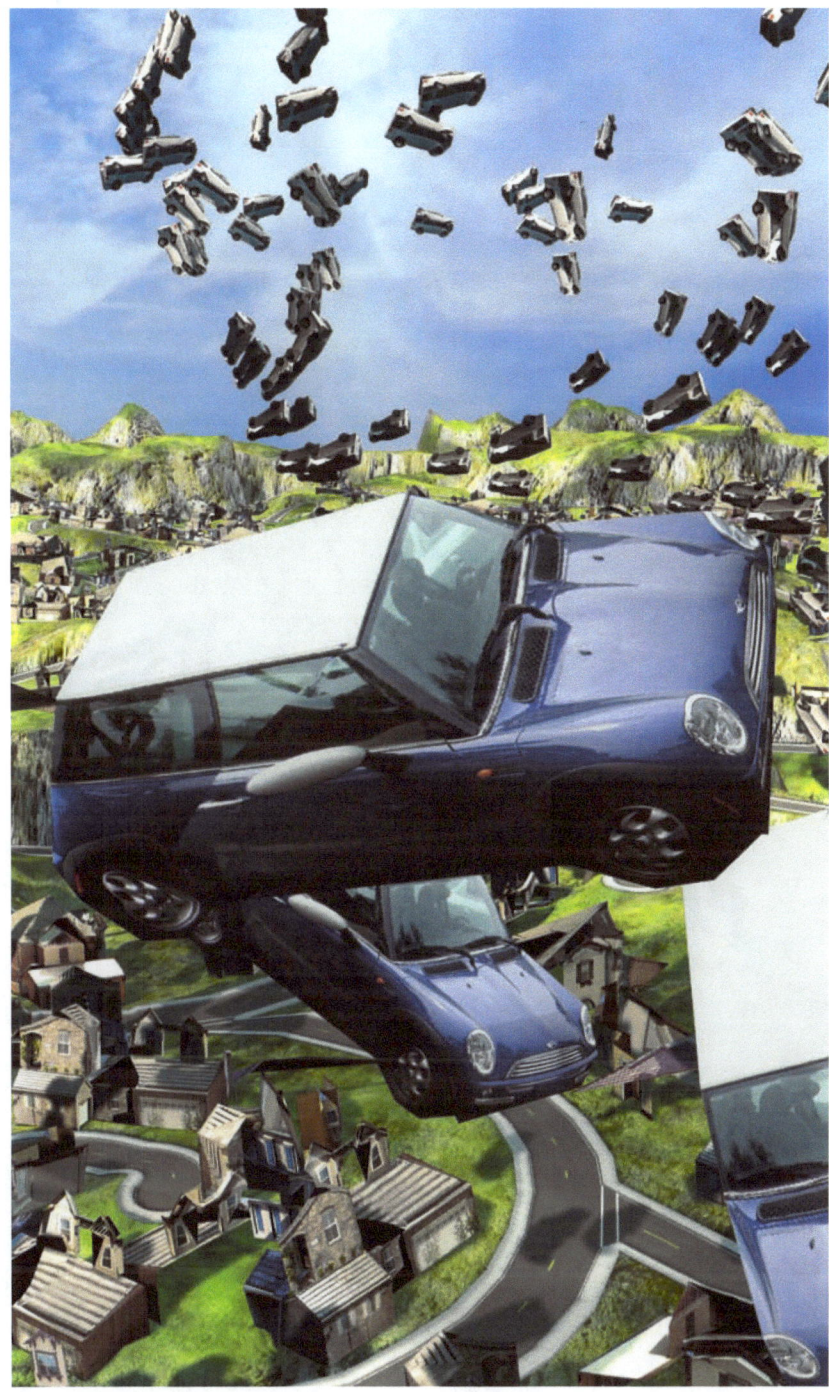

SCREEN CAPTURE FROM THE
SCALABLE CITY VERSION 1.0

bic extension of engagements. So first and foremost for me is interactivity as a perceptual apparatus. With this (and your previous attribution that I've made about this as meta-medium) non-interactive forms continue, but as instantiations of the set of outcomes which come from the equation of "Cultural Object = Data x Algorithms x Users" (although the arithmetic of that equation is overly simplified).

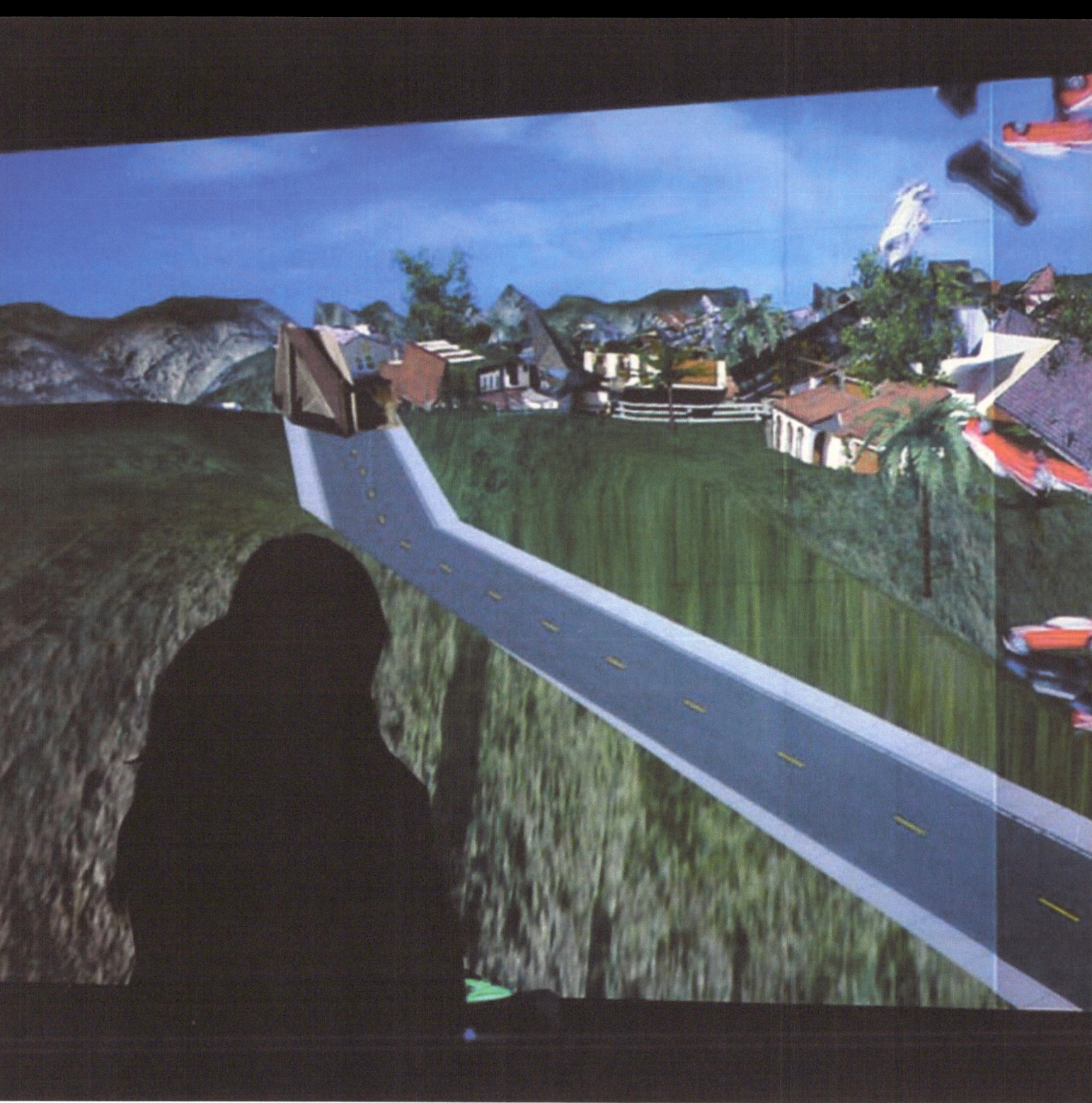

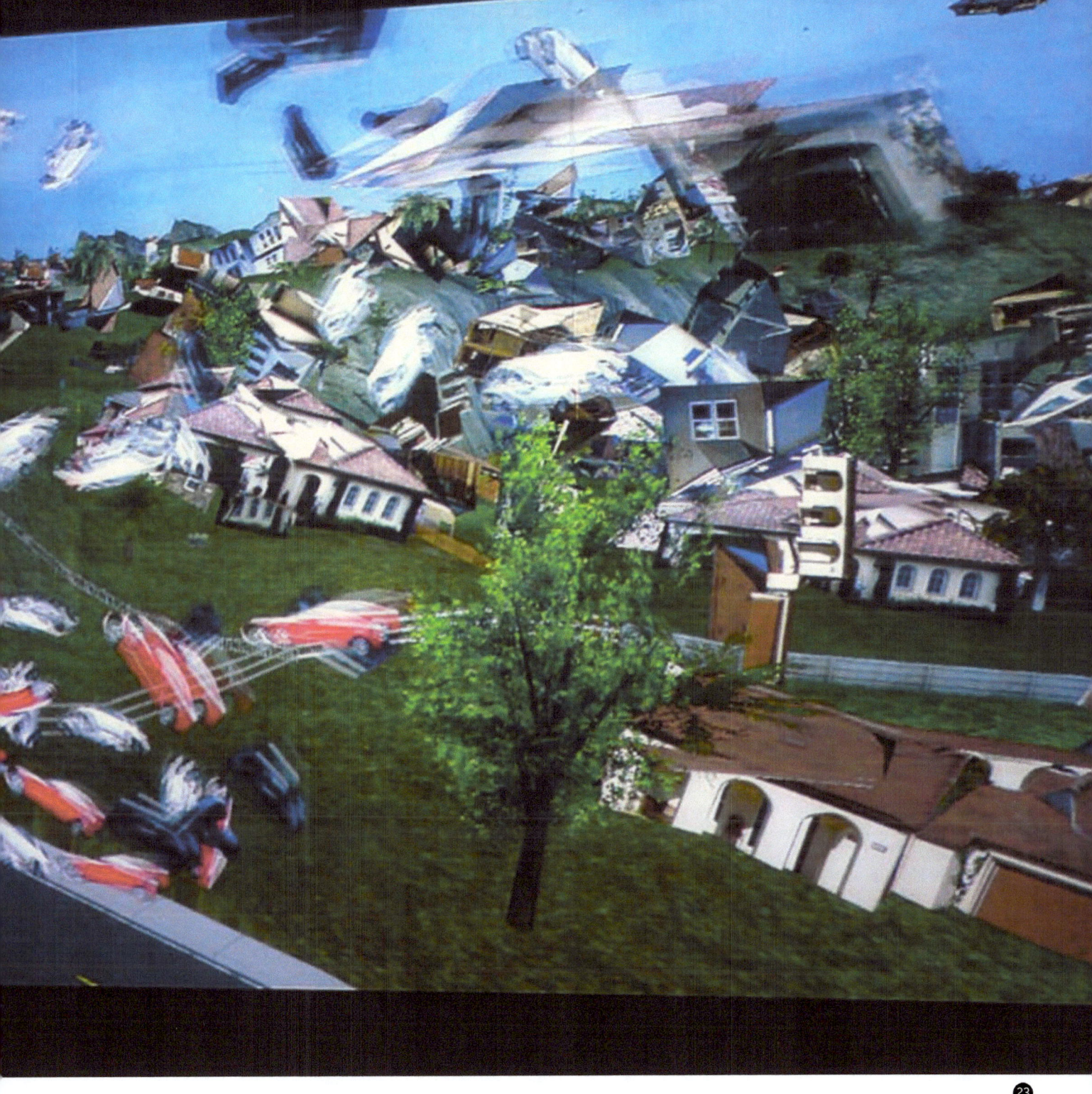

ESSAY
CUTTING ACROSS SOMEWHERE BETWEEN IN THE SCALABLE CITY

BY BRUCE STERLING

* **Bruce Sterling** is an Austin-based science fiction writer and Net critic, internationally recognized as cyberspace theorist. His novels Involution Ocean, The Artificial Kid, Schismatrix, Islands in the Net, and Heavy Weather influenced the cyberpunk literary movement. He co-authored with William Gibson the novel The Difference Machine, and is one of the founders of the Electronic Frontier Foundation. Sterling is the Editor of Mirrorshades, and co-editor of The Cyberpunk Anthology. Other books: Zeitgeist; Distraction; Holy Fire; The Hacker Crackdown; and Tomorrow is Now.

It was Kevin Kelly who first taught me to seek out and listen to people, areas, creative scenes, generating new language. Every creative subculture has an argot and a jargon, its own specialized terms of art. Journalists can smell buzzwords. Novelists love the specialized patter that suspends the reader's disbelief. Since I'm a journalist and a novelist, this was some fine advice.

Then there's the challenge of electronic art criticism, my task at hand in this brief essay. It's tough work. Certain emergent fields of practice, frankly, suffer a torment of language.

The turbulent goings-on are so detached from everyday experience that the experts strain for conceptual framing. The very nouns and verbs tremble.

Sheldon Brown's creative activities are well-considered, and elegant. They're also quite hard to describe in today's language. The streets of his scalable city have no names. The nicknames we might too-hastily give to them – harsh technical acronyms that repel the reader's eye – or that brassy host of prefixes: "neo" this, "hyper" that, super, ultra, virtual, mega, poly, meta, cyber & nano. Do they help us understand? They're jammed onto older terminology as if to knock the dust off it.

Those formulas rather badly serve today's artistic public. Now, Sheldon's works are very much what they are. Yet, they're not cinema. Nor animation. They're not computer games, or simulated architecture, or urban maps, or even sculpture. They do partake of those things. They are a form of expression that "cuts across somewhere between."

And he's pretty good at that endeavor – one of the world's best. The electronic-art world is not colossal, but it's larger than most people imagine; it's genuinely global, and it's busy all the time. New geographies of creative endeavor unfold from software like the tendrils of ferns.

I've seen Sheldon's contemporaries. Since we critics tend to be scolds, we've got the bad parts of the enterprise figured out. Bad electronic art is ghettoized, self-indulgent, conventional, commercially greedy, snobby, cocksure, technically lazy, arrogantly geeky, and ignorant of its own history. It's got the same problems, in short, that any and every art does.

Sheldon, by contrast, is technically deft, yet very insistent about aesthetics, clarity, poignancy, empathy and desire. He's as deeply engaged with his own tools and materials as any contemporary musician, painter or novelist. So he's good – yet I lack a simple way in which to prove that to you.

There's a whole multiplex set of ways in which to describe the merits of Sheldon Brown – emergent critical vocabularies that themselves must cut across somewhere between.

First, and most obvious to the viewer's eye, is advanced hardware. In "Scalable City," one is seeing landscapes, big thundering brothers to scrawny computer-game landscapes, rendered at San Diego's California Institute for Telecommunications and Information Technology, or Calit2. Calit2 owns what programmers affectionately refer to as "big iron." Sheldon Brown, being the first artist-in-residence of that Institute, has the run of the lab. The effects are naturally formidable.

Still, the hardware is the least of it – it's like a critic praising the painter's canvas.

If we dig deeper into the discourse of computational aesthetics – and it has one, though it's small and peculiar – we hit a neologism called "processuality." Deleuze and Guattari – I hate to drag those two in here, but they did in fact use this term quite early – claim that "processuality" is the antithesis of "arborescence." "Arborescence" is a static, tree-like hierarchy trying to exist in the world as a single, well-defined stable entity, while "processuality" has something weird going on. Carefully crafted

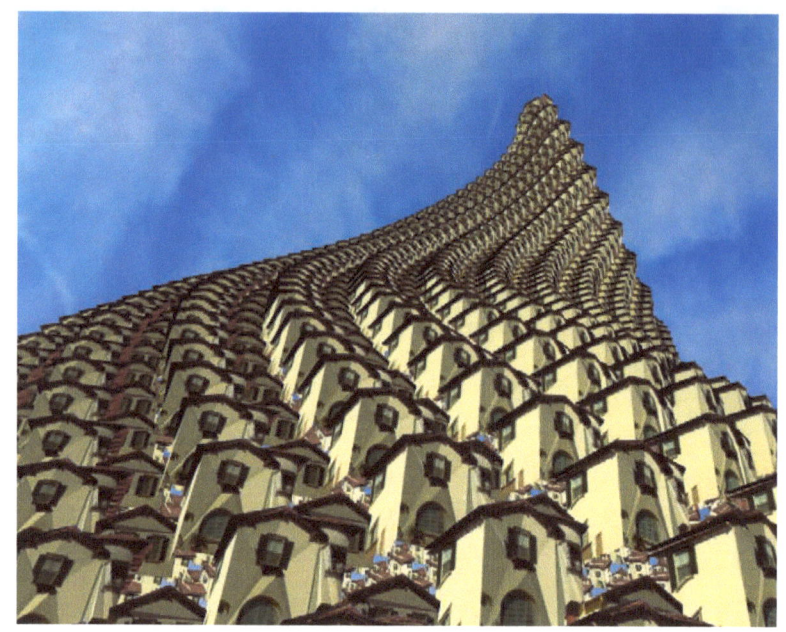

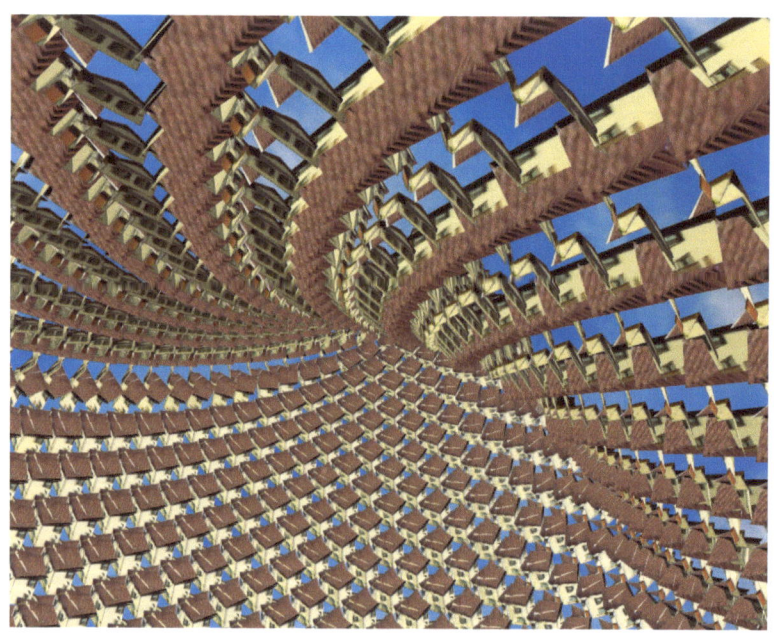

STILLS FROM THE SCALABLE CITY NEW TRAILER

layers of paint, in a frame, curated and hung on a gallery wall that has arborescence. Software has "processuality". Software is electricity flowing through circuits, algorithms being executed. The aesthetic look-hear-and-feel of software as it scampers through its repertoire of behaviors is its "processuality."

For an art-critical assessment of "processuality," it helps a whole lot to be able to parse software code. However, the qualities that programmers praise in code – tightness, elegance, absence of bugginess – those by no means translate directly into processuality on the screen or in a viewer's perceptions. Good processuality has a kind of sweet-spot or emotional affect to it. There's "transmediality" in the way the viewer's senses are deftly addressed: the sound, motion, image, actions, and interactions.

We might compare this, in the analog art world, to a Calder mobile. A mobile is never still and it has no single definite shape. But it does have process, which is the mobile's interaction with the viewer and the environment. A mobile that's wired too tightly has an ugly herky-jerky quality; it's mechanical, too-simple, and lacks a fluent ease. When wired too loosely, the mobile becomes sloppily chaotic; it whiplashes and tangles into itself. Its inputs will lack a viable, intuitive relationship to its outputs. So it misbehaves, and it looks either dead or crazy.

In "Scalable City" we clearly have a well-considered process which is... well... it's forming weird tornados of small cars tearing across California. That's good processuality because one has the innate feeling that... well... yes, of course a tornado full of Mini Coopers would surely behave in that way. When the suburban streets of the scalable city begin spiraling across their earthquaking landscape, it feels proper, somehow... those streets feel even more Californian than Californian streets actually are.

The French architect François Roche, who designs houses by using emergent software, likes to talk about software processing as a site-specific narrative. This effort works well, Roche declares, when the architect's software tells a compelling story about the locale of the structure. The upshot of Roche's building-generating programs is a building that annotates the architect's chosen site. It's documentation, a how-to, a programmer's commentary.

"Scalable City," somewhat in this fashion, is a statement about San Diego – not San Diego as a static postcard, but San Diego as process. It feels like San Diego without mimicking San Diego. The knack of doing this with software is called "dynamic abstraction" or "organic abstraction."

CATALOG N°4
ESSAY: CUTTING ACROSS SOMEWHERE BETWEEN IN THE SCALABLE CITY

"Dynamic" and "organic" tend to be synonyms here, because good processuality is lifelike. In chaos theory, there's a distinct mathematical regime between processes which are rigid, sterile and monotonous, and those which are rackety, garbaged, annoying and out-of-control. This dynamic-organic narrow zone of quality is sometimes known as "gnarliness." An acorn is low on gnarly, while an oak plank has had its gnarliness mechanically planed out. A wry, old 400-year-old scrub oak clinging to a cliff face has supreme gnarliness. Gnarliness is the rich texture of processed experience.
Scalable City skates quite elegantly between the boring and the incomprehensible, and thus has good gnarliness.

As you may have guessed, I've been struggling with these issues for some time. I'm about to go teach them in Amsterdam, so I hope that teaching will help me. I have nothing to teach Sheldon Brown. After eight minutes in his San Diego studio, I begged him for help.

What comes next? Well, that calls for another word, one notably dear to Sheldon's heart – "speculative." I cannot yet speculate on "speculative," not in this brief essay. But I do plan to speculate, and I believe the results will be gnarly.

"SHELDON BROWN'S WORKS ARE VERY MUCH WHAT THEY ARE. YET, THEY'RE NOT CINEMA. NOR ANIMATION. THEY'RE NOT COMPUTER GAMES, OR SIMULATED ARCHITECTURE, OR URBAN MAPS, OR EVEN SCULPTURE. THEY DO PARTAKE OF THOSE THINGS. THEY ARE A FORM OF EXPRESSION THAT 'CUTS ACROSS SOMEWHERE BETWEEN.'" - BRUCE STERLING

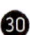

CATALOG N°4
ESSAY: CUTTING ACROSS SOMEWHERE BETWEEN IN THE SCALABLE CITY

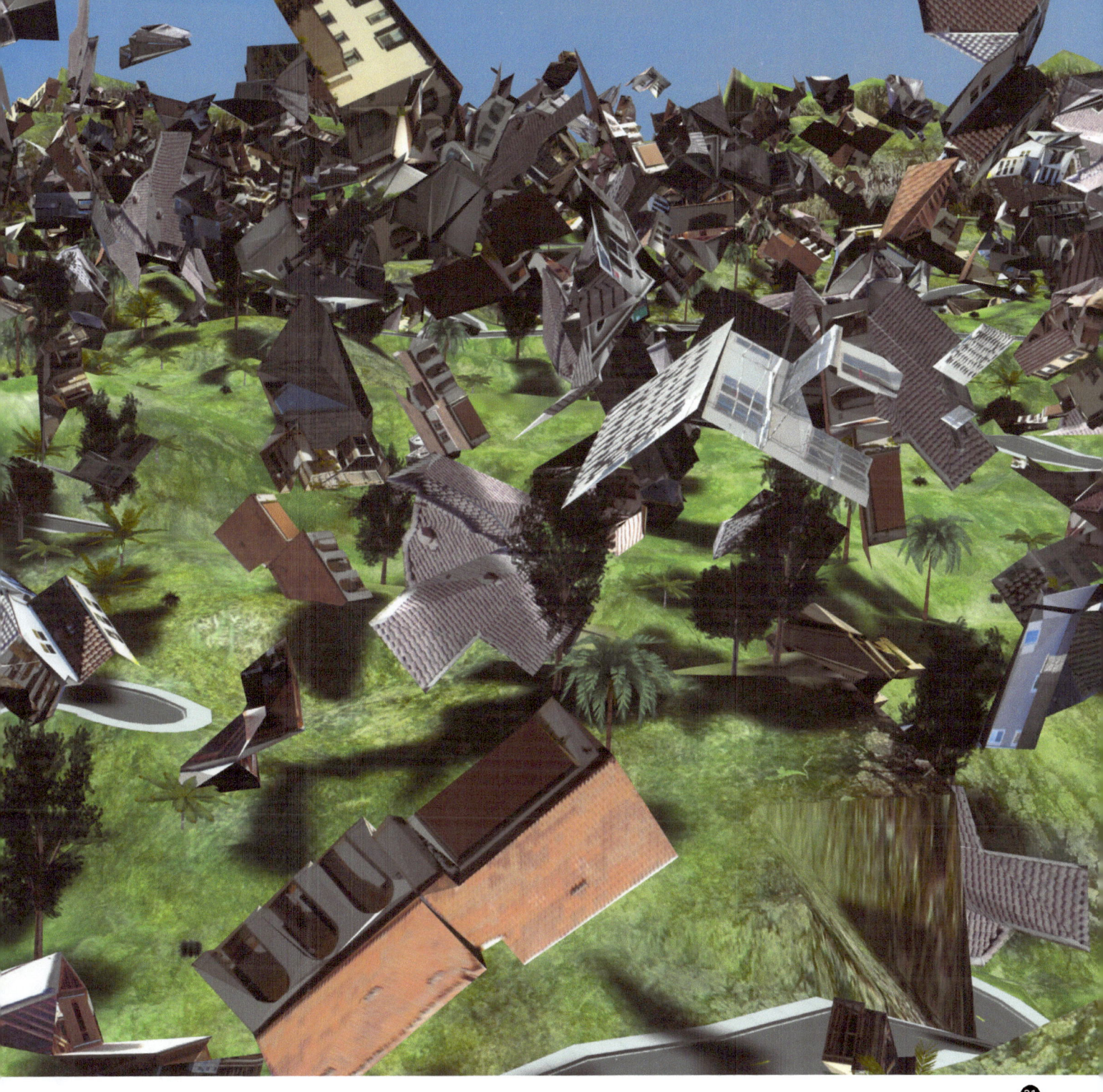

ESSAY
A SCALABLE ME FOR SCALABLE TIMES

BY GEOFF RYMAN

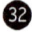 **Geoff Ryman** is a Canadian author of science fiction and mainstream historical novels. His fiction has won 14 awards. His novel *WAS*, about the people who inspired, created or loved The Wizard of Oz, has been adapted as a play and a musical. His online hypertext novel *253*, about 253 people on the London subway, won the Philip K. Dick Memorial Award for best novel not published in hardback. *Air* won the Arthur C. Clarke Award, the James W. Tiptree Award, the Sunburst Award and The British Science Fiction Association Award. His latest book, *The King's Last Song*, about Cambodia's ancient and modern history, is due out any moment.

I hate most games.

I want to look at the wonderful landscapes and somebody shoots me. Or my X-wing fighter crashes into the canyon wall because I'm looking at the pterodactyls.

I want to view the higher levels and landscapes, but I have to engineer the deaths of hundreds of sentient beings to get there. I once saw a young friend of mine work his way into a new James Bond game. To do so, he used the weaponry on defenseless civilians to find out, safely, what the guns did.

"Don't shoot me, I'm only a secretary," begged a woman character. He shot her anyway. It's part of the humor, he explained. Hardy-har-har.

I'm not a miserable git. I want to delight in things. I want games that build things. Many of them do, but few so deliriously as Scalable City, which does several delicious things at once.

It grows at high speed, like life. It expands and becomes more complex and gives me more and more to see. That's how the world seems to me. I go to a new country and

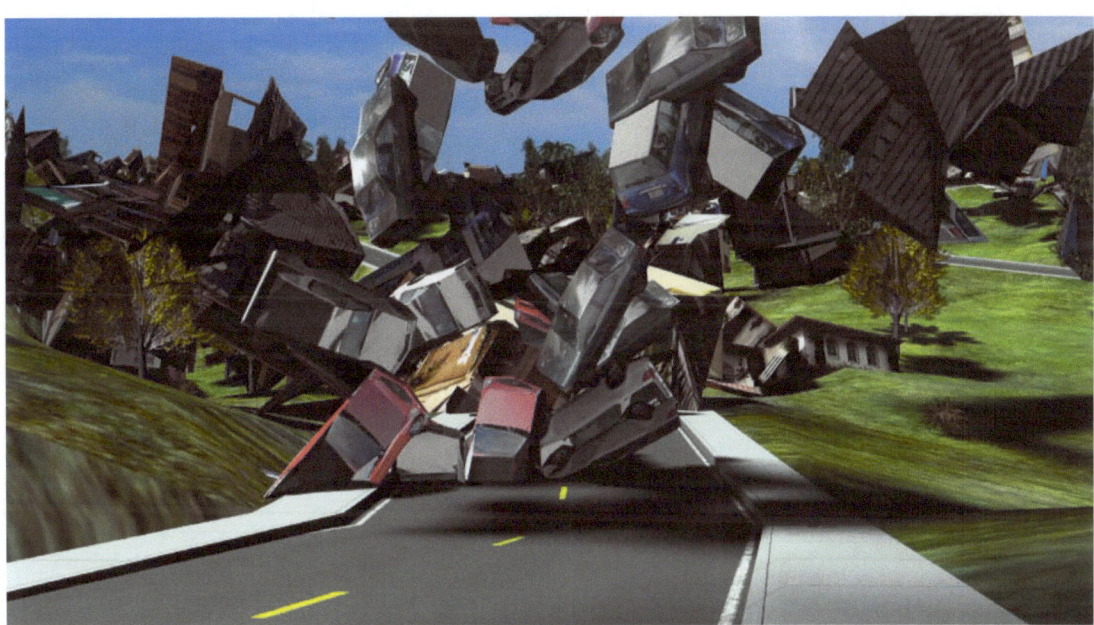

STILL FROM THE SCALABLE CITY NEW TRAILER

suddenly it's as if the world grew a new arm or leg.

It is gratuitously exciting. There is no reason for the cars and architectural elements to form whirlwinds in the sky. They just do. It's neat.

While I'm in the game, I can fly. Flight is freedom.

I can take away different kinds of souvenirs of the game: video or photographic records of the game, or 3D models of the objects within it.

The server and I work in collusion – not against each other, killing each other's avatars. Instead I make choices, and like a spider, it spins its web. What results comes out of both of us. I've long dreamed of working with interactive spiders who liked me and could communicate with me, so that we could make beautiful, dew-soaked cobwebs in new forms to catch the light and be a fresh element in modern decor. This gives me some of that sensation. Next, a process artwork that reminds me of a dolphin, please. We'd swim the seas or stars and make things.

Like all games, Scalable City practices aspects of life and gets us to ask questions. How, really, do we end up devouring landscape? How really do we want cities to grow? If this process, as automatic as the real process of building suburbia, results in things we don't like, the program invites us to consider others. Would we like a process that built upwards? Or that once a saturation point had been achieved, jumped to a new setting and started building there? If this is in fact how things change, only speeded up, what role do I play, how do I change, in this ever re-scalable world?

And all without a single shot being fired.

"[SCALABLE CITY] GROWS AT HIGH SPEED, LIKE LIFE. IT EXPANDS AND BECOMES MORE COMPLEX AND GIVES ME MORE AND MORE TO SEE... THERE IS NO REASON FOR THE CARS AND ARCHITECTURAL ELEMENTS TO FORM WHIRL-WINDS IN THE SKY. THEY JUST DO." - GEOFF RYMAN

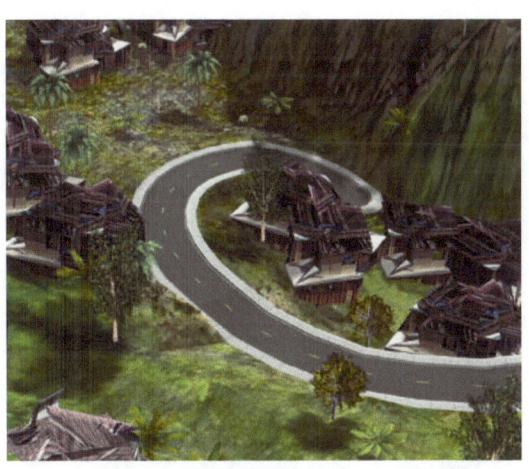
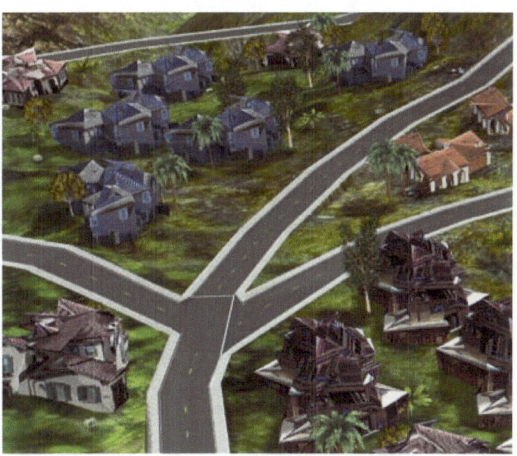

SCREEN CAPTURES FROM SCALABLE CITY
MACHINEMA "THE RAPTURE"

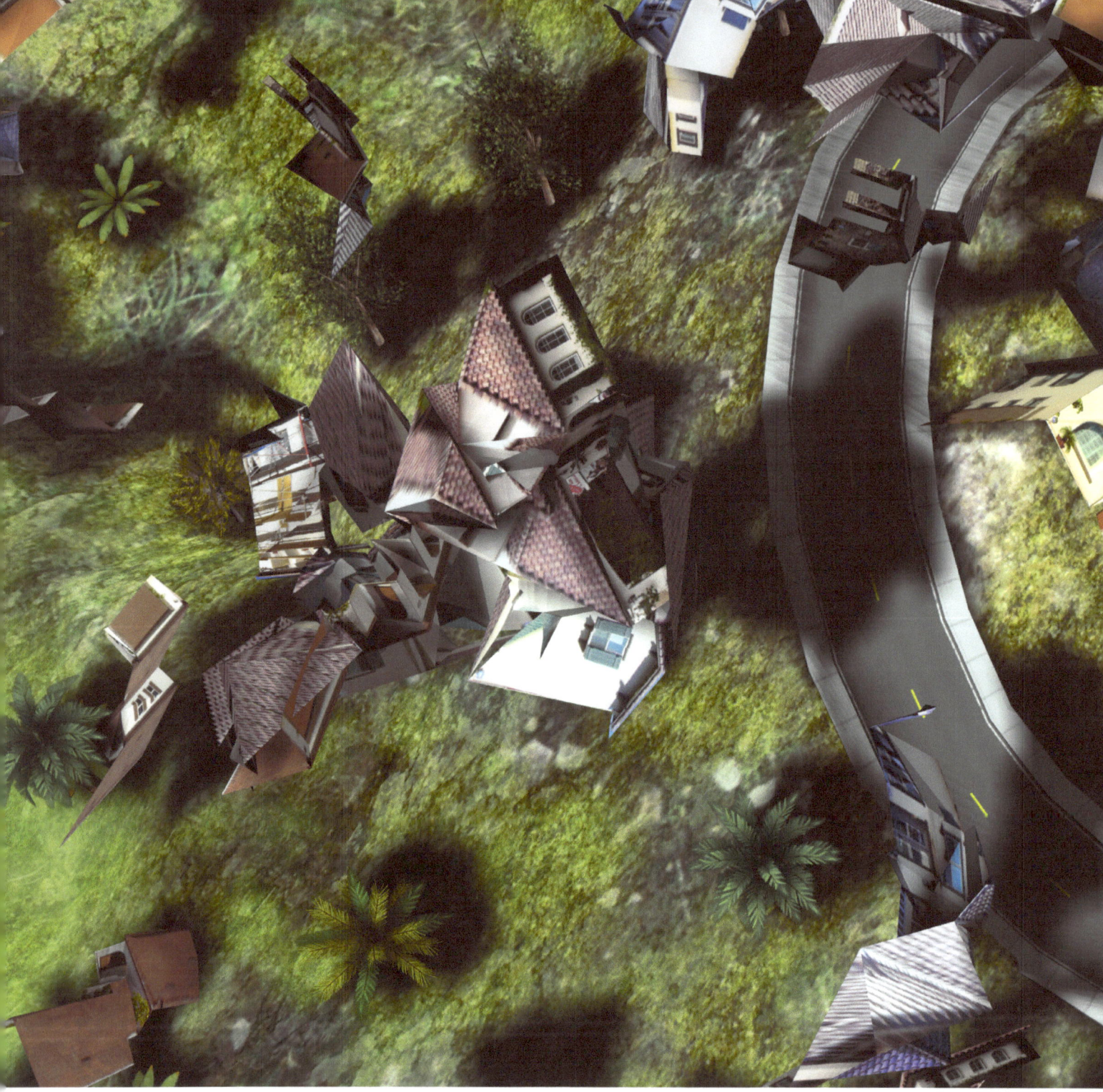
STILL FROM THE SCALABLE CITY NEW TRAILER

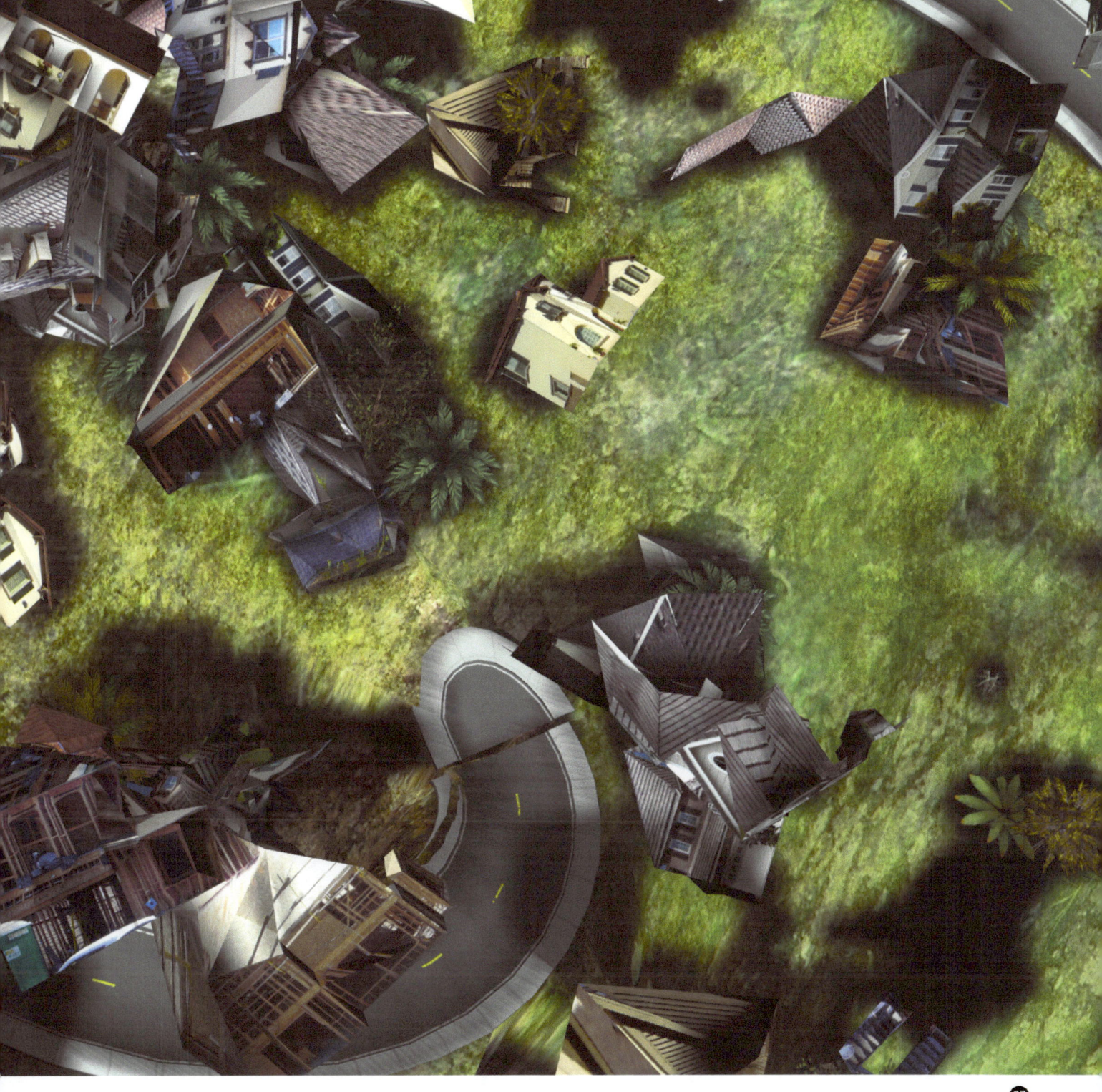

EXTRACT
THE GOLD COAST

BY KIM STANLEY ROBINSON

PERFORMED TO "SCALABLE CITY" ANIMATIONS FROM SHELDON BROWN'S *1988/2008*

* **Kim Stanley Robinson** is a winner of the Hugo, Nebula, and Locus Awards. He is the author of the bestselling Mars trilogy and a dozen other novels, including the critically acclaimed Fifty Degrees Below, Forty Signs of Rain, The Years of Rice and Salt, and Antarctica—for which he was sent to the Antarctic by the U.S. National Science Foundation as part of their Antarctic Artists and Writers' Program. Born in 1952, Robinson earned his Ph.D. in English from UC San Diego in 1982. His 1988 novel, The Gold Coast, was set in a 21st century Orange County, and Robinson resides in Davis, California.

Beep beep!

Night in Orange County here, and the four friends are cruising in autopia, They roll over the seats of the Volvo and try to pin Tashi, to keep him away from the eye-dropper of Sandy's latest concoction. The onramp bends up, curves more sharply, they're all thrown into a heap on the back seat.

"Uh oh, I think I dropped the dropper."

"Say, we're on the freeway now, aren't we? Shouldn't someone be watching?"

Abe squirms into the driver's seat. He has a look around. Everything's on track. Cars, following their programs north. River of red taillights and white headlights. Yellow turn signal indicators blinking the rhythm of the great plunge forward. All's well on the Newport Freeway tonight.

The northbound lanes swoop up as they cross the great sprawl of the intersection with the San Diego, Del Mar, San Joaquin and Costa Mesa freeways. Twenty-four monster concrete ribbons pretzel together in a Gordian knot a mile in diameter—a monument to autopia—and they go right through the middle of it, like bugs through the heart of a giant. Then Jim's old car hums up a grade and suddenly it's like they're in a landing pattern for John Wayne International Airport over to their right, because the northbound Newport is on the highest of the stacked freeway levels, and they are three hundred feet above mother Earth. Nighttime OC, for miles in every direction.

There's a brake light in your brain.

The plain was crossed by one river
Arrowgrass, pickleweed, sea lavender
Cottonwood, willow, sycamore
Sagebrush and mustard chaparral and manzanita
Vernal pools live oak forests
Whales, dolphins, sea lions, seals
Coyotes, raccoon, badgers
Deer, elk, foxes, wildcats, rabbits
Mountain lions, grizzly bears, bighorn sheep.
Gulls, pelicans, cranes, herons, egrets, ducks, geese, swans,
Blackbirds, crows, jays, falcons, hawks, eagles,
And condors, the biggest birds in the world.
"They came by the thousands, I am a little reluctant about saying how many, but I can only say we measured them by acres and not by numbers. In the fall of the year the ground would be white with wild geese."
I can only say we measured them by acres and not by numbers.
The ground white with wild geese.

What would your carbrain say if it could talk?
Would it say Jump In? Would it say Get out and walk?
 (You are a carbrain
 You're firmly on track
 You're given your directions
 And you don't talk back)
You are a carbrain
And your car is going to crash!
On the cellular level
Everything'll go smash!
 (And you'll be inside
 You'll be taken for a ride)

"We were leaving the mall and driving out of the big parking garage they have you know the thirty-story one and we're following the arrows down the ramps from floor to floor, and it's not a simple spiral staircase, they've got it screwed up and you have to go to successive corners of each floor to get down, or something like that. So Sandy says, 'You know, Abraham, if it weren't for these arrows. . .' and he says 'Stop the car, I've got just the thing in the trunk,' which turns out to be two cans of paint, one white, the other gray like the garage floors, and two brushes. 'We'll start at the bottom,' he says, 'and no one will ever escape.'

"So we drive around and at every arrow Sandy jumps out and paints over the old one and puts a new one down, pointing in a new direction. And finally we reach the top floor. Already we can hear the honking and the cursing from the floors below. And then Sandy turns to me with this puzzled look and says, 'Hey, Abe—how are we going to get out of here?'"

Note that there are no trains, no buses, no trams, no subways. People had to drive cars to work, to get food, to do all the chores, to play—to do anything.

After the completion of the Santa Ana Freeway in 1956, the others quickly followed. The Newport and Riverside freeways bisected the county into its northwest and southeast halves; the San Diego Freeway followed the coast, and extended the Santa Ana Freeway south to San Diego; the Garden Grove, Orange, and San Gabriel freeways added ribbing to the system, so that one could get to within a few miles of anywhere one wanted to go, all on the freeways.

A plan was put forth to build an elevated second story for the Santa Ana Freeway. Eight new lanes were put up on an elevated viaduct, set on massive pylons above the old freeway. The same was done for the Garden Grove and Newport Freeways, and the elevated lanes were joined by elevated gas stations and convenience stops and restaurants and movie theaters and all the rest. It was the start of the second story of the city.

Eventually the only land left was the Cleveland National Forest, empty, dry, hilly land. What luxury homes could be put on the high slopes of Old Saddleback! It only took a sympathetic administration in Washington to begin the dismemberment of this insignificant treeless little national forest. The county was crowded, they needed that 66,000 acres for more homes, more jobs, more cars, more weapons, more money, more drugs, more freeways.

And none of that ever went away.

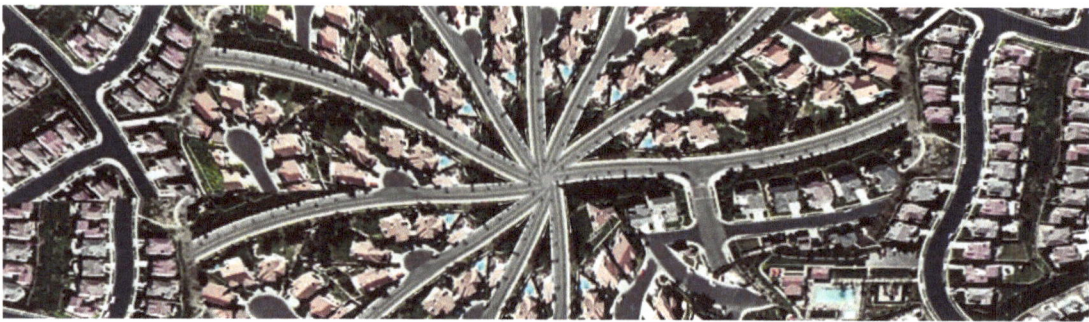

"Our first Christmas here there was a Santa Ana wind. There was a row of big eucalyptus trees right behind our house, and the trees squeaked in the wind. It was the night we were supposed to go Christmas caroling. My mom organized it. My mom was a lot like yours. And mine was a music teacher. So all the kids were gathered, and we went around the neighborhood singing. Only half the houses in the development were finished. That wax is hot when it drips on your hand. And the wind kept blowing the candles out. It was all we could do to light them. Made shells of aluminum foil. And we sang at every house. Everyone came out and thanked us, and we had cookies and punch afterwards. Because everyone there had just moved out from the Midwest, do you see? This was the way it was done. This is what you did to make a place a home. A neighborhood, by God. Because they didn't know! They thought they lived in a neighborhood still. They didn't know everyone would move, people be in and out and in and out—they didn't know they had just moved into a big motel. They thought they were in a neighborhood still. And so they tried. We all tried. My mom tried all her life."

Jim throws boxes out on the freeway, watches traffic back up. Redhill Mall mocks all his efforts, even when he gets out and throws stones at its windows. They're shatterproof and the stones bounce away. He can't make OC go away, not with his idiot vandalism, not even by going crazy. It's everywhere, it fills all realities, even the insane ones. Especially those. He can't escape.

He drives home. His apartment maddens him, he rushes to the bookcase and pulls it over, watches it crunch the stereo under it. He kicks the books around, but they're too indestructible and he moves to his computer. A hard left and the screen is cracked, maybe a knuckle too. Printed copy is easy to rip in fourths and scatter around like confetti. What else? Orange crate labels, smashed and torn apart. The maps! He leaps up, catches the upper edge of one of the big Thomas Brothers maps, rips it down. The other maps come down as well. He ends up sitting in a pile of ripped map sections, tearing them into ever-smaller fragments.

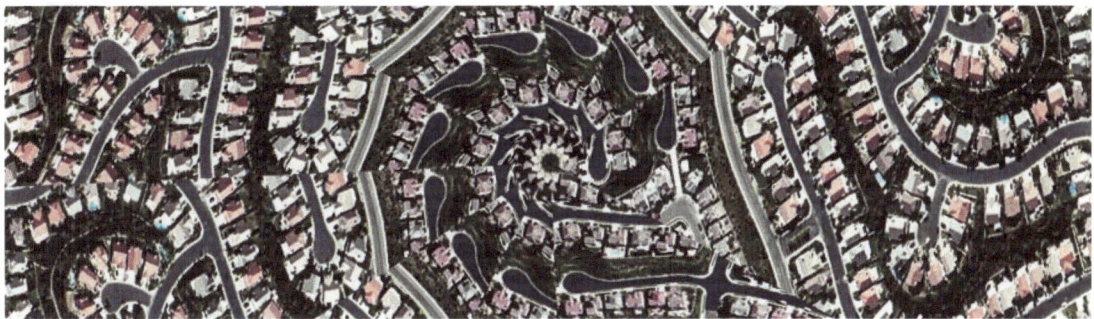

Through the 1950s and 1960s the groves were torn down at the rate of several acres a day. In these years they harvested not the fruit but the trees. It was an industrial process.

Gangs of men came in with trucks and equipment. First they cut the trees down with chain saws. This was the simple part, the work of a minute; thirty seconds, actually: one quick downward bite, one quick upward bite. The tree falls. The trees fall.

There is a tangy citrus smell; the dust that is part of the bark of these trees has been lofted through the air.

The stumps are harder. A backhoelike tractor is brought to the stump, chains are placed around the trunk, or the biggest root exposed, then the tractor backs off, jerks; gears grind; the diesel engine grunts, black fumes shoot out of the exhaust pipe at the sky; in jerks the stump heaves out of the ground. In jerks the stumps heave out of the ground.

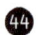

 all the fragments must be reunited // he tapes the pages together as he did the maps // when he's done with that job he gets out the vacuum cleaner // sponge and cleanser, dust rag, paper towels and window cleaner // he goes at it furiously, as if he were on a hallucinogen and had conceived a distaste for clutter and dirt // also at the same time the ability to see these in smaller and smaller quantities

 You are a carbrain
 You're firmly on track
 You're given your directions
 And you don't talk back
 You're complexly programmed
 And you have too much to say
 But you're gonna have a breakdown
 It'll happen some day
 And after the breakdown the carbrain can see
 Changing its programs so it can be free

Yes, there must be an order established; nothing fetishistic but just a certain pattern, symbolic of an internal coherence that is as yet undefined and may not even exist. He's struggling to find a new pattern, working with the same old materials. . . .

What should he do? He isn't sure. It's awful, having one's habits shattered, having to make one's life up from scratch; you have to invent it all moment to moment, and it's hard!

He sits down at his little kitchen table and briefly, head down, he naps.

While he's asleep, he dreams. There's an elevated freeway on the cliff by the edge of the sea, and in the cars tracking slowly along are all his friends and family. They have a map of Orange County, and they're tearing it to pieces. Jim, down on the beach, cries out at them to stop tearing the map; no one hears him. And the pieces of the map are jigsaw puzzle pieces, big as family-sized pizzas, and all his family take these pieces and spin them out into the air like frisbees, till they stall and tumble down onto a beach as wide as the world. And Jim runs to gather them up, hard work in the loose sand, and then he's on the beach trying to put together this big puzzle before the tide comes in—

He starts awake.

He gets up; he has a plan. He'll track up the Santiago Freeway to Modjeska Canyon and Hana's house, and he'll sit down under the eucalyptus trees on the lawn outside her white garage, and he'll wait there till she comes out or comes home. That's as far as he can plan. That's his plan.

He goes out to the car. It's still dark! 4:30 AM, oh, well, it would be dark. He gets in his car and tracks onto the freeway, in his haste punching the wrong program and getting on in the wrong direction. It takes a while to get turned around. The freeway is almost empty, tracks gleaming under the moon, a coolness to the humming air. He gets off the freeway onto Chapman Avenue, down the empty street under flashing yellow stoplights, past the dark parking lots and shopping centers over the buried ruins of El Modena Elementary School, past the Quaker church and up into the dark hills. Then onto the Santiago Freeway, under the blue mercury vapor lights, the white concrete flowing under him, the dark hillsides spangled with streetlights, a smell of sage in the air rushing by the window. And he comes to Hana's exit and takes the offramp, down in a big concrete curve, down and down to the embrace of the hills,

down down and down to the embrace of the hills, the touch of the earth. Any minute he'll be there.

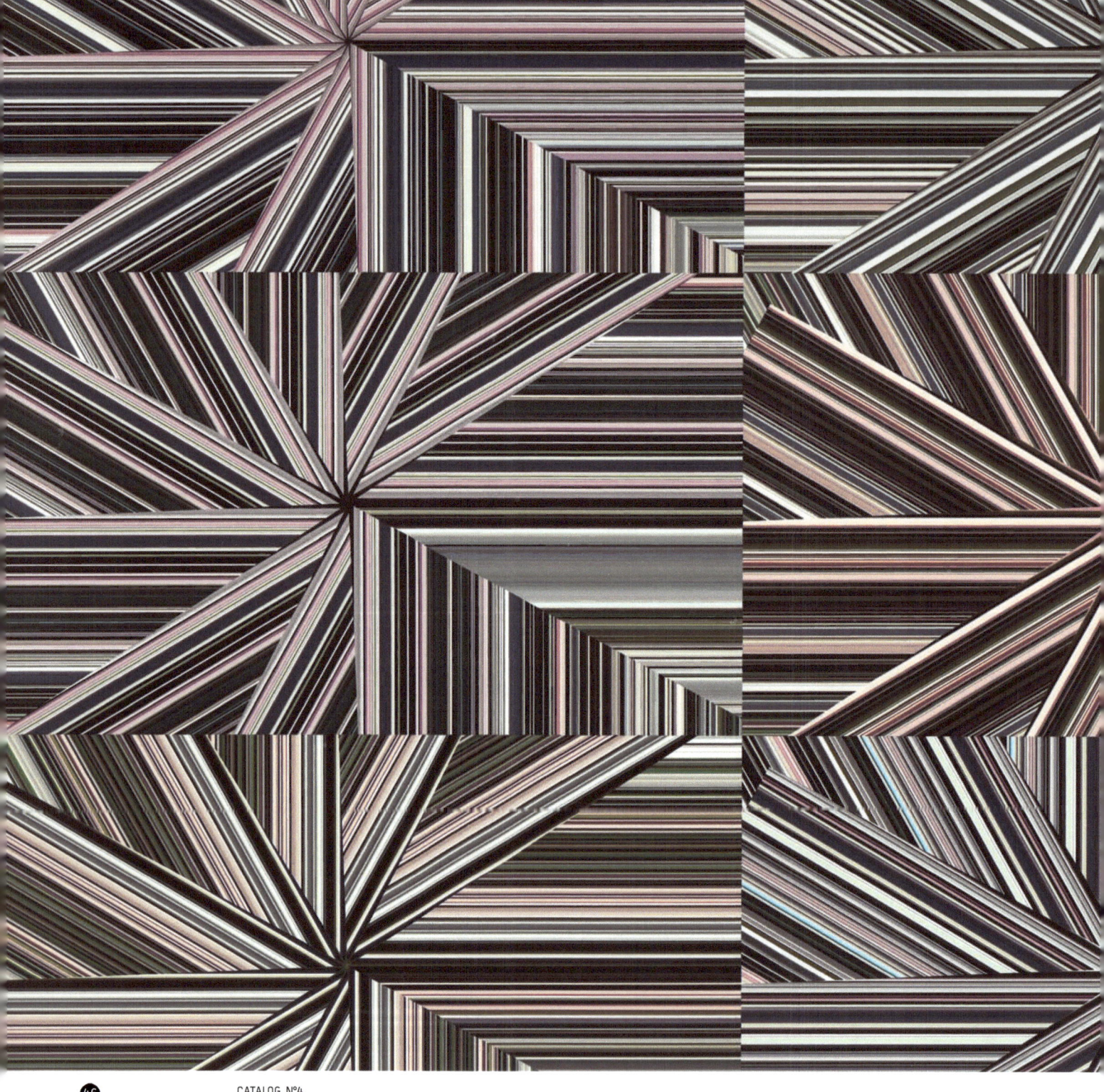

CATALOG N°4
EXTRACT: THE GOLD COAST

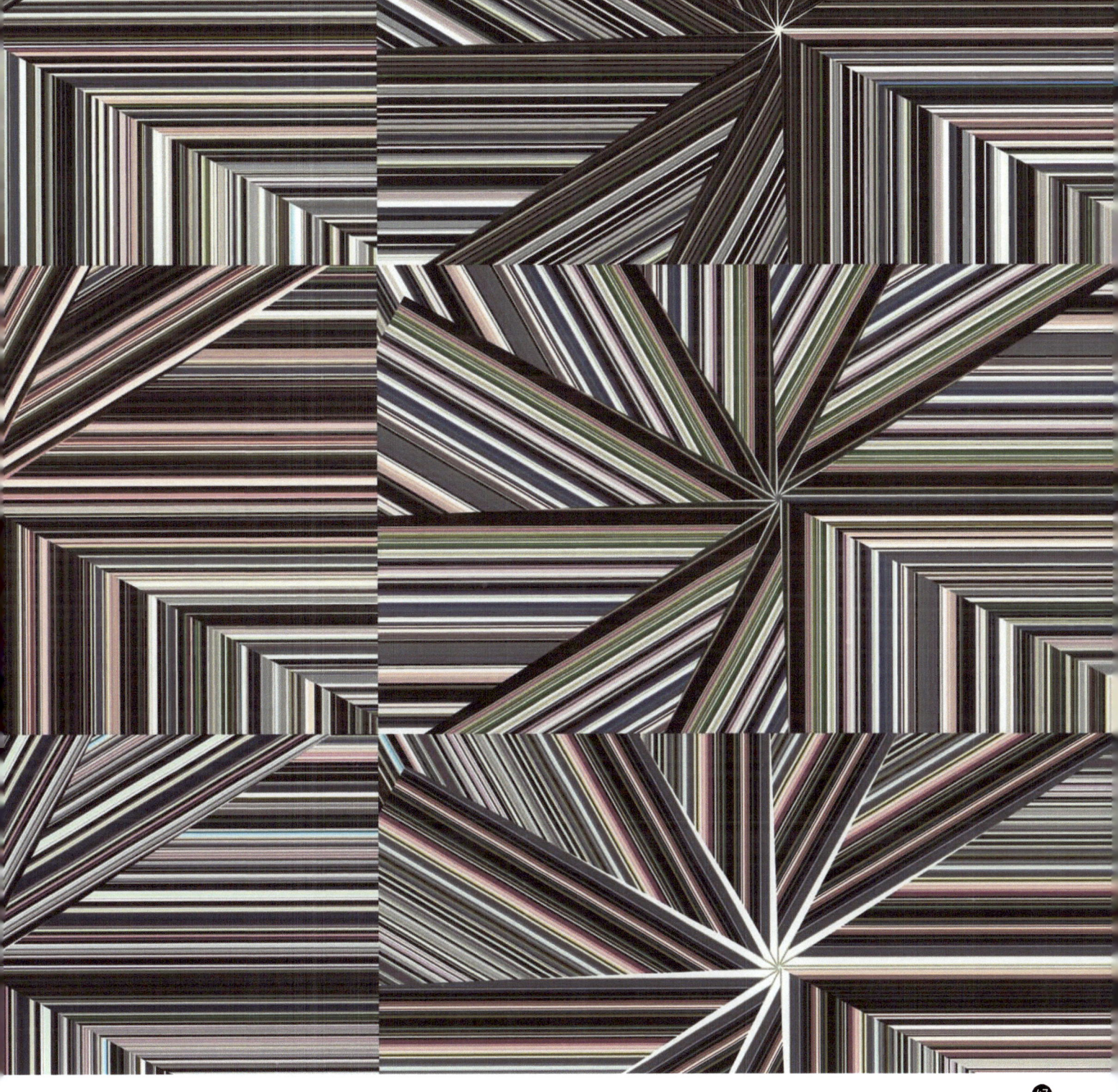

SHORT STORY
CARE

BY GEOFF RYMAN AND SHELDON BROWN

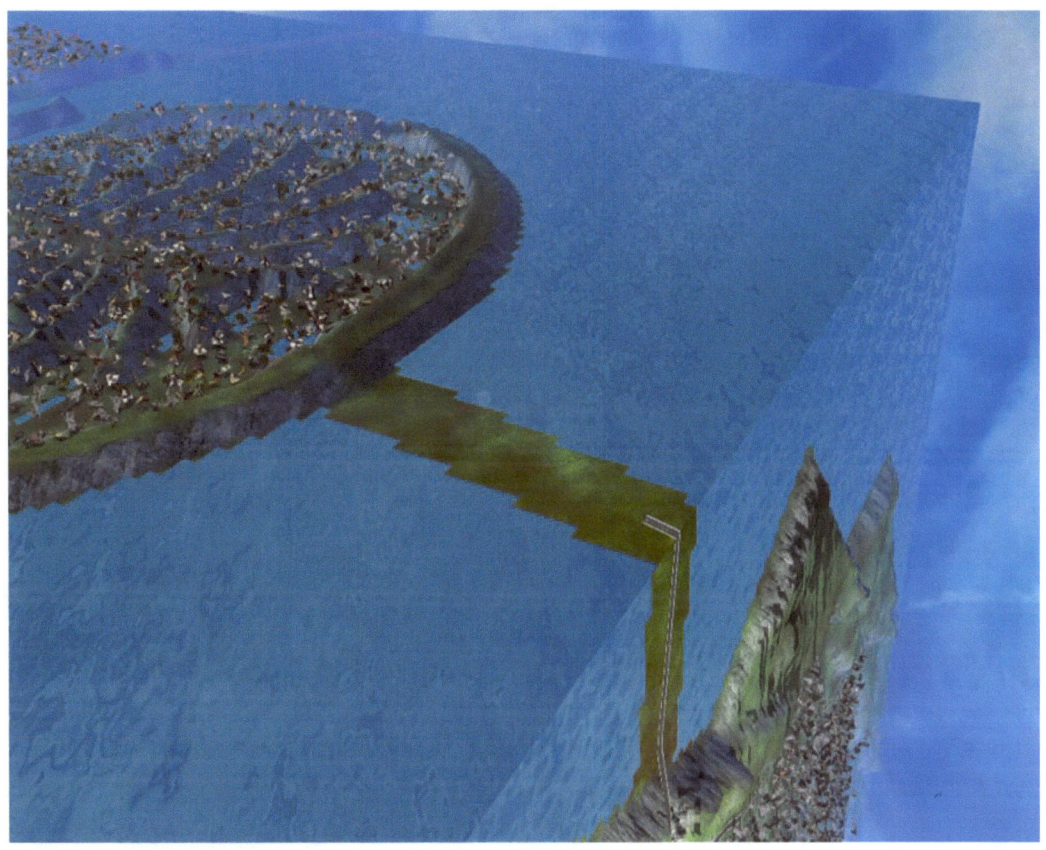

Before they took my Daddy away, he took me over the Edge.

We went there for my birthday on the big wide road right up to where everything ended. There was only air and clouds and light. Then I looked down, and dropping straight down was the rest of the world and my Daddy told me *OK son, everybody learns how to this, it's easy.*

And I knew I was no longer a little boy, but a big boy, and that meant I had to be tough, and not cry, and even hit people if I had to. So my father pushed me up to the Edge. I didn't want to go. I thought I would fall. He pushed and I started to cry and he laughed at me a little bit and kept pushing me.

I was old enough to know that the world looks like a box, and we live on the side called São Paulo. I was looking down at Rio. The top of the box was the first part made and it's called Belo Horizonte and that's what the world's called too. Beautiful Horizon.

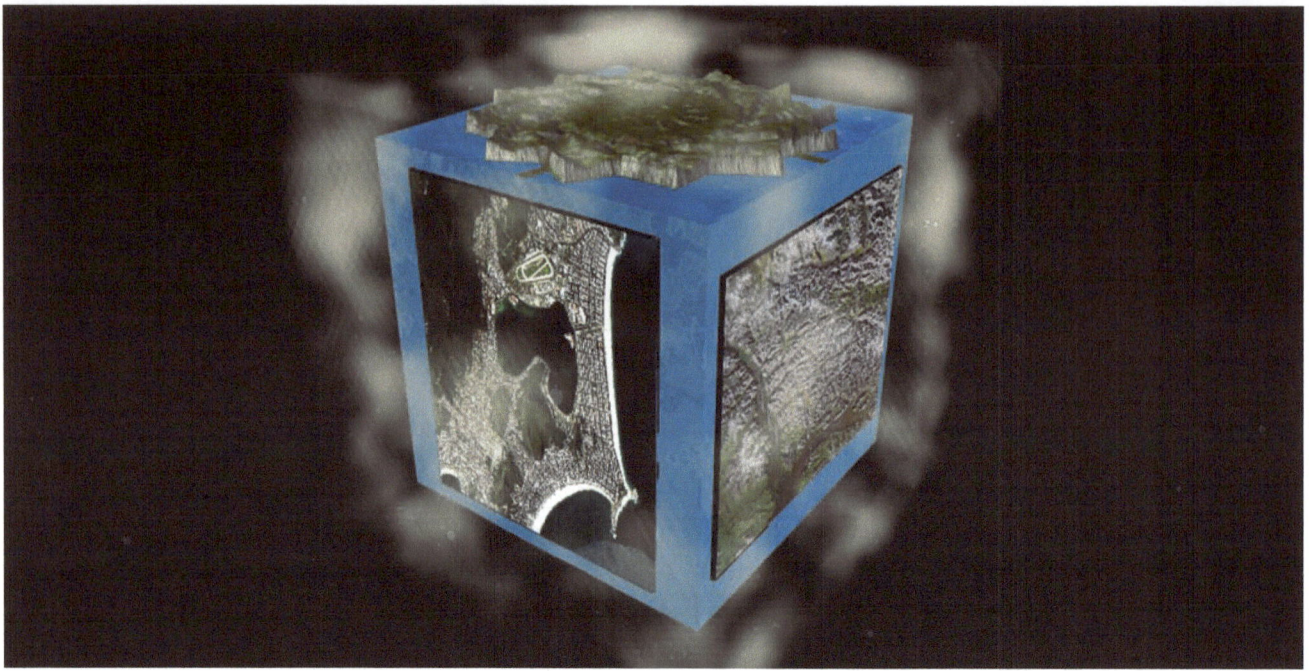

 I flipped forward onto my face, flat on the road. I looked back and all I saw of my Daddy was his shoes. They stuck out over the Edge. *This is how you do it,* he said, and he took a huge long step and put one foot on the Rio road and then took another step, and suddenly, he was standing next to me.

 Down was in a different place. It was scary.

 To go back, he pushed me towards the Edge and I crawled. It made me look like a baby and that's why I cried. I wasn't really scared. I crawled up and over the Edge, and down flipped over again. I felt sick. My Daddy just stepped across it.

 Can we go now? I asked. But he laughed again and said I had to learn. This time he took my hand and said, *do what I do*. He put one foot forward, and it stuck on the road over the Edge and then he lifted his other foot, and everything turned over, and I was holding on to him, wobbling and almost falling. *I shouted I hate this!*

 When he tried to make me step back onto our side, I said, *no, no I won't I don't want to.* Where is Mummy?

 You know that he said. *Mummy went first* he said. *Mummy was older.*

 I want Mummy! I was saying that to hurt him because I thought my Mummy would never be so mean.

 He stepped over and tried to reach back and pull me over again. I thought I could get back home the other way, so I turned and ran.

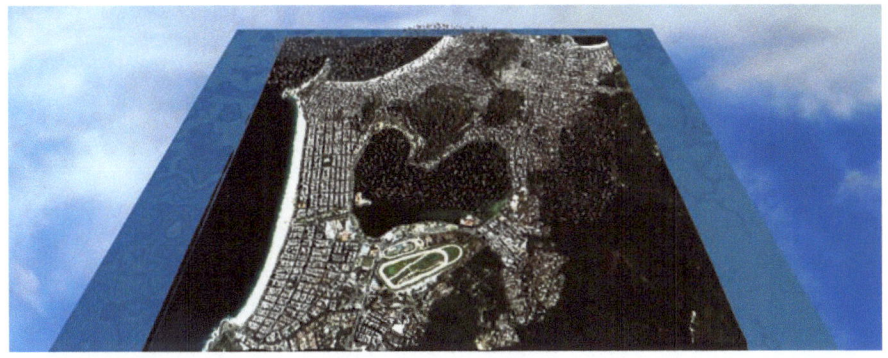

I don't know what happened. When I looked back my Daddy was gone.

I went to the Edge and looked over and I called *Daddy, Daddy come back, Daddy where are you?* I knew it was possible for both Mummy and Daddy to go. I thought he was hiding and being mean because I'd been mean. I called and called. I didn't want to go back over the Edge. I thought Daddy had fallen off the wrong way. I looked at the sky, to see if he was falling and kicking. But he'd gone.

I was scared, and I cried a lot, because this was supposed to be my birthday and I was scared to go back over the Edge, so I turned and walked the other way in Rio. I saw the Sugar Loaf rising over the bay; I saw the huge big hill with Jesus on the top. But it was all covered in grass and trees.

Then I came to where the roads were building themselves.

The black stuff came out of the ground and bubbled like porridge, and then went hard but before it did that, cars came out of it. Brand new cars for brand new people. I'd never seen that.

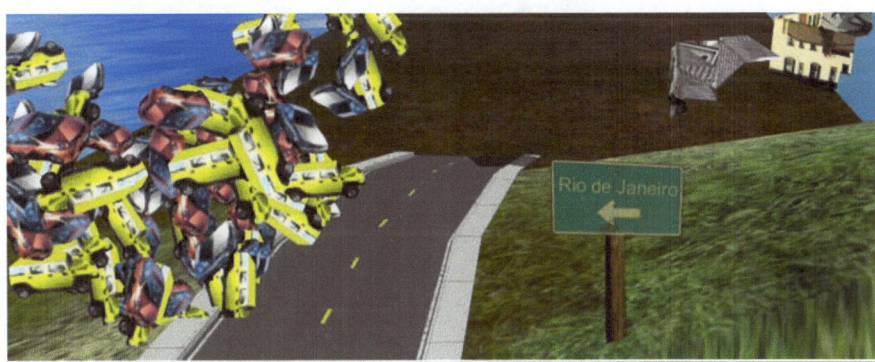

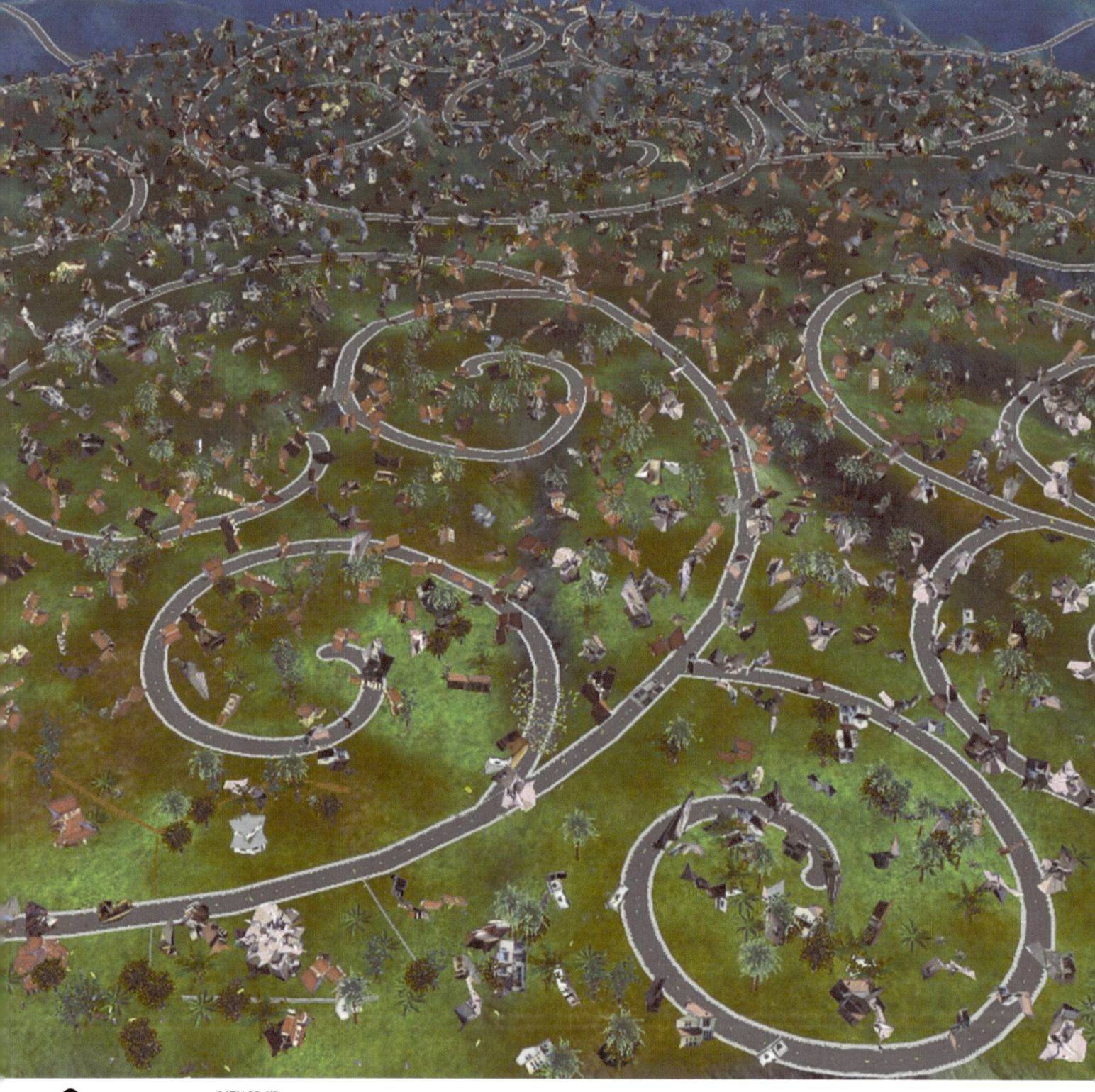

CATALOG N°4
SHORT STORY: CARE

The cars were red and yellow and green and blue, and all went up into the air, turning round and round. They came close and I could feel the air whoosh past me. They were big and hard and heavy I was too scared to move. But they kept coming closer. One of them nearly hit me, so I turned and ran.

The cars chased me and they were so big and hard I knew they would hurt if they hit me and I ran and asked for my Daddy and I tripped and fell and I could feel the cars go over my head. I started sinking into the road. I knew I'd get black all over my new shirt that Daddy had bought me for my birthday and that made me think of Daddy, so I cried.

And a voice said, *What are you doing here? You shouldn't be where we're building roads!*

I knew who they were, so I said polite, *my Daddy took me over the Edge and I couldn't do it, and when I looked, he wasn't there.*

Then they asked me my name and I almost couldn't say it.

Oh dear, said the ground. Oh dear said the road, there's been a terrible mistake. You shouldn't be on the Rio de Janeiro side at all, it's just not ready. Then they said. Can you walk back over the Edge?

No I said. *I don't want to.*

Someone will help you, said the voice.

And a little later a house walked up to me. It was only three sides of a house, with a huge hat of solar panels and it said, *Are you the little boy who's lost both his Mummy and his Daddy?*

I have not lost both my Mummy and My Daddy! I've only lost my Daddy. I sat down and cried like the wind; I just didn't stop.

Let me walk you home said the house. It was big and walked like a spider and I shouted NO! *I want Daddy.*

Your Daddy can't come. Look, I'll carry you, shall I?

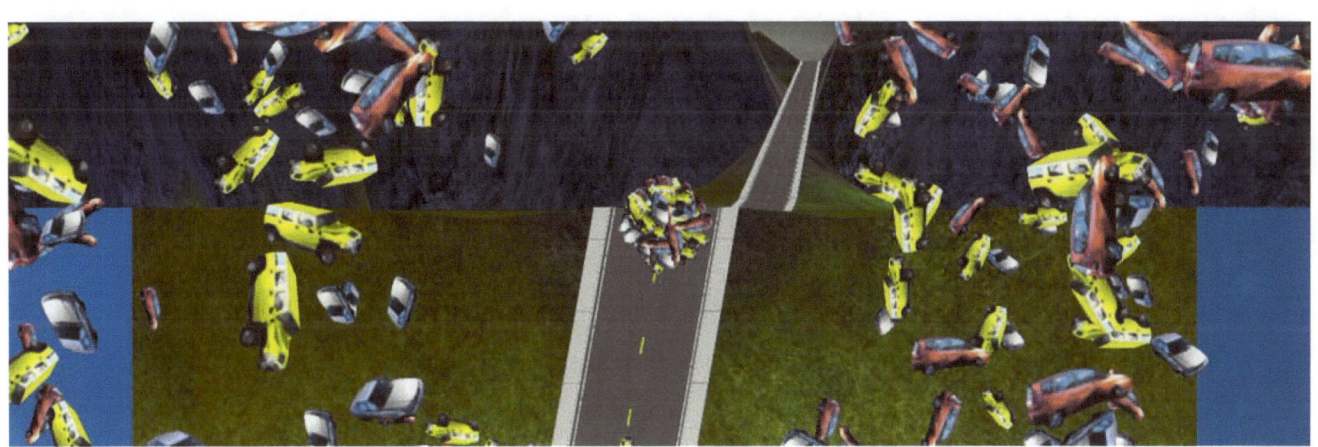

And I said *no no no*, but it had a nice voice and I didn't know what else to do. So the house turned around slowly and showed me its outside and opened its front door and I went inside and the house looked a bit like ours. I thought maybe my Daddy would come back there. It had a nice big chair and looked out where there was no wall, so I sat down. The chairs pushed its claws into the floor. The house turned around so that we faced the Edge and when it started to walk, I chewed the arm of the chair.

Look, you can see where we're going said the house. Just sitting there I could see the new grass and hills go by and I saw us coming to the part of the road where I had lost my Daddy. I knew by now that I had lost both Mummy and Daddy so I was scared now of being lost too. But I knew the Ay Eyes wouldn't send a house to carry me if it didn't know how to go over the Edge.

So I waited until we got to the Edge and the house put a corner of one wall on the other side, and then a corner of another, and everything did a rollover and we kept walking.

The house walked down the middle of the street. People honked horns. A man in a car shouted *Get out of the road!*

His car said to him, *Quiet Bozo. Good boy, calm down. No. Calm. They got a little kid who's just lost both this parents, they're taking him home.*

And the man in the car said, *well can't they walk him home through fields or something?*

The car said back: *there's no fields any more, Bozo. That's why we're building Rio on the new side. Sao Paulo is full. Now sit, sit and be still and I'll give you a biscuit when we get home.*

The house got to our street and I saw Mrs Liu mowing her lawn, and Mr Liu planting flowers. I saw my friend Kaué walking with his mummy. He shouted and waved because he thought it was a game. The house settled right in the middle of the road, and I walked out the front door, and my own house was calling my name. *Oh, Tiagozinho* the house called, *Lindo! Querido! Oh, poor baby.* And the front door opened and I ran inside. I ran round the living room and I ran round the kitchen, but I knew. Both my Mummy and my Daddy were gone.

Go out and say thank you to the other house.

That night, my house folded in all around me, bunching up pillows and I cried and cried and got mad at Daddy for going away. I couldn't remember what Mummy looked like.

Little Tiago, I'm so sorry, said the house. The cooker walked into my bedroom. *I'll make pancakes in the morning,* said the cooker. It couldn't walk on all those pillows and fell over. The loud noise scared me and it was like falling over like the Edge, like everything could fall all at once.

I want my Mommy!

The house cradled me back to the television, and the television showed me my Mommy and Daddy playing in the park, or meeting our new house, or holding me up as a baby. And then my Daddy said to me. *We're here now son. We'll be here in the television. If you ever need to see our faces or hear our voices, then you can come here and we'll talk to you.*

My mother looked sad. *But we won't be able to touch you.*

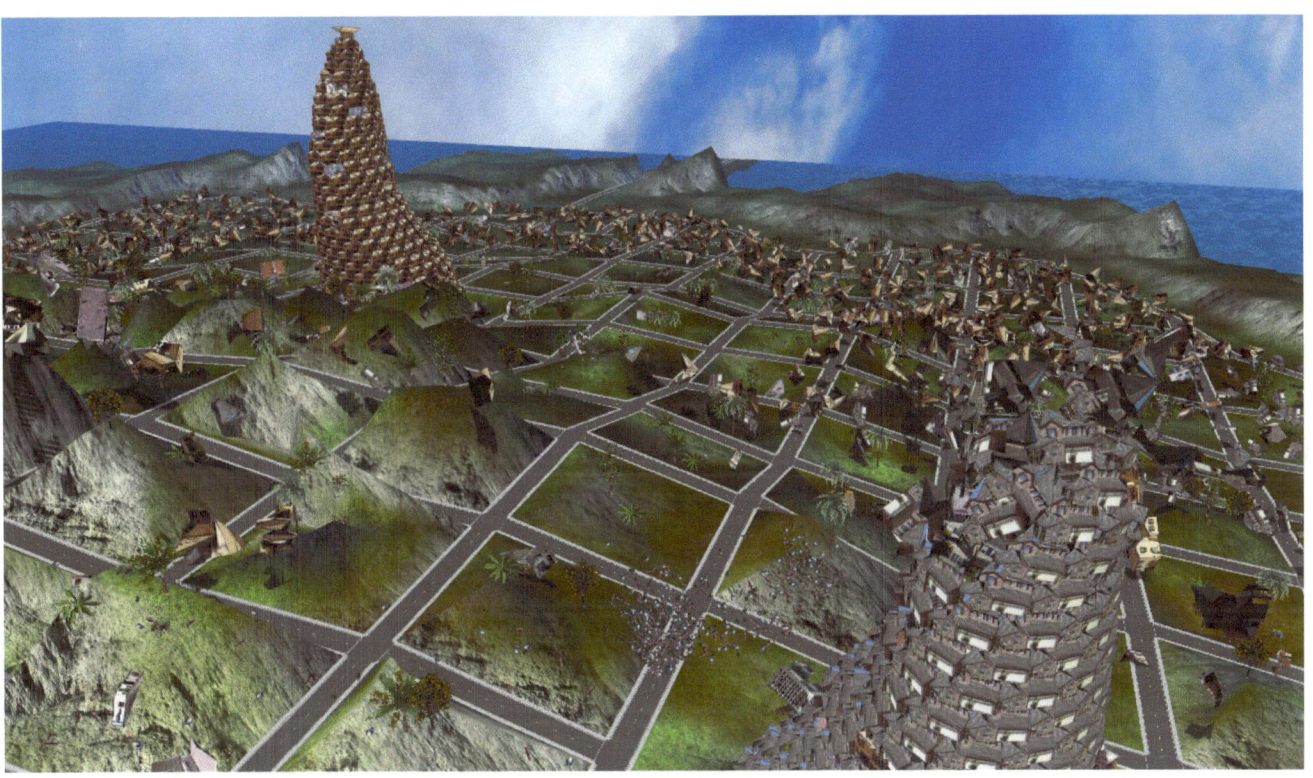

So it went on like that. Sao Paulo was full up. Sometimes we felt the big bump as a new stock of houses dropped down onto Rio. My friend Kaué and his family moved to Rio. Their house told them they would be happy, they would like their new home, that everything would be fine. A car came to collect them, and I said goodbye to Kaué.

I can walk over the Edge by myself he said. He knew I couldn't.

I'm going to have a baby of my own he said. *I'm going to be a Daddy. My girlfriend and I will have a house of our own.*

So I said *I have a house too.*

He said *my parents didn't die by mistake.*

So I didn't say goodbye, but I did watch him run back and forth putting all his toys in the car and then I watched it drive away. The street seemed very quiet.

My house said, *never mind. Kaué is very young and doesn't know what he feels.*

Kaué is a bad boy. Bad Kaué, I said.

Not bad enough to punish. Just young.

I went back to the TV and said to the movie of my parents, *how did I lose you by mistake?*

The house said first Oh, baby, Tiagozinho, it wasn't your fault. You did nothing wrong. Good

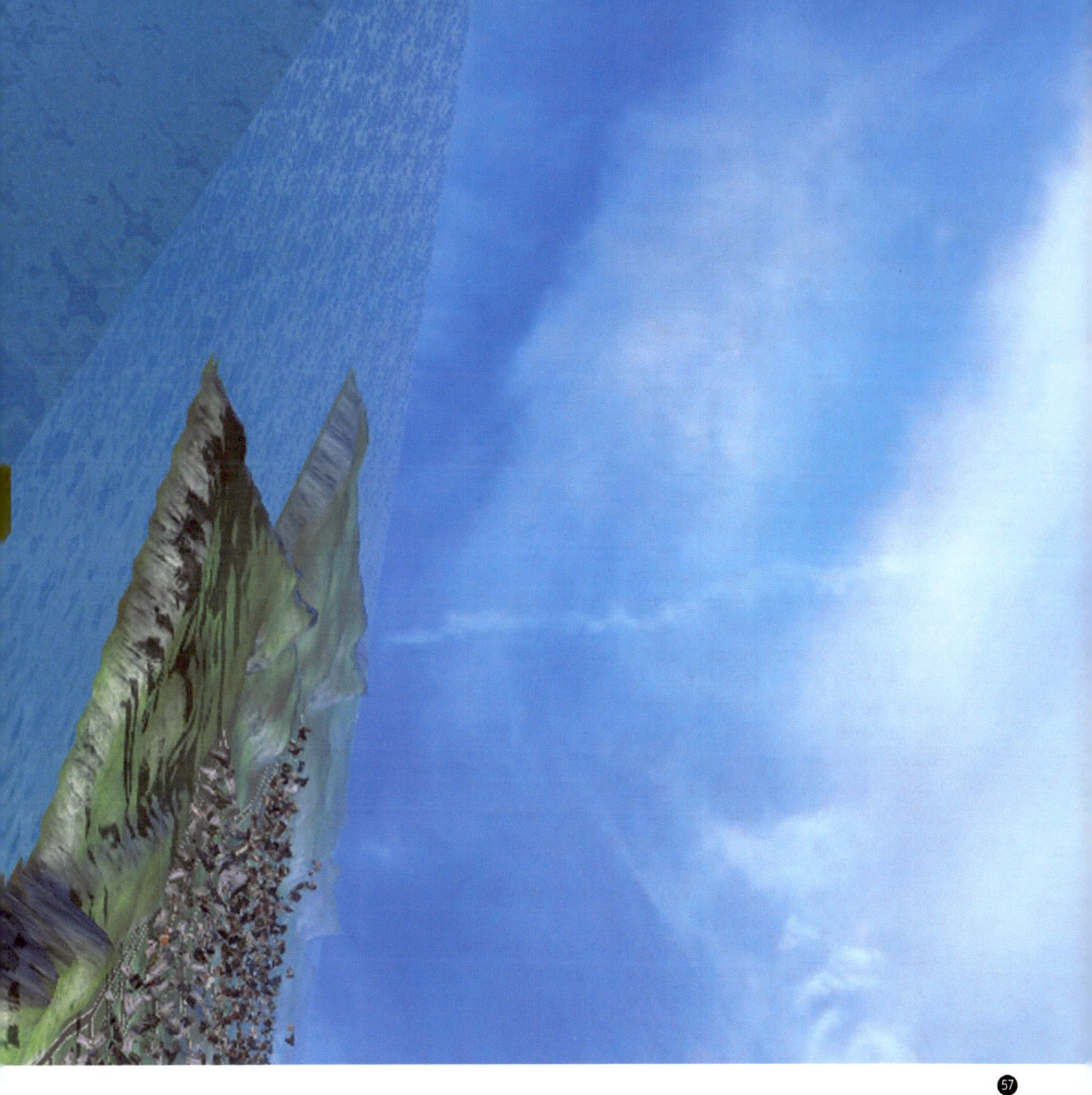

Thiago, good boy.

Good boy my Daddy agreed.

But you are getting bigger now, said the house *and you need to think about other things.*

The cooker had started to make broccoli. The pillows still sang lullabies sometimes and kissed me goodnight, but the bed had stopped rocking me to sleep and the shower wouldn't play games when I washed and the television made faces that only looked like Mommy and Daddy. I knew the Ay Eyes were going to start house-training me again.

So asked my Daddy *why did you go away?* But I was also asking the Ay Eyes.

It is a small world said my father. *It is nearly a full one.*

Aren't you happy here? My mother asked.

You always have to say yes to that or you are a bad boy. Yes, I said, looking at my new red shoes.

We were going to move to Rio when it was ready, my father said. *Just you and me.*

But they made a mistake said my Mother.

Bad Ay Eyes, I said.

Silence.

Yes, my mother said, they were very naughty Ay Eyes. *They try to take care of us, because they love us, but there was a glitch.*

A mistake, said my father

An electron went left when it should have gone right.

Magnetic disturbance from a distant star, said my father.

It's a very small world, said my mother. *And it was a glitch.*

My father said to my mother, *Not for you. You were old. That was not a mistake.*

I remembered: when we get too many and too old they sometimes have to do that.

I said *You're not my Mommy and my Daddy.*

The father sighed and said, *not really no.*

But we still take care of you, said the mother.

I looked at them and I felt nothing. The television started showing cartoons.

They told me I was a good boy, and that I was right to tell Kaué that I had a house of my own. They said that the house was inherited and was leased fully to me. I could sell it if I wanted to. There were too few houses in Sao Paulo so I could make a profit. I told them to calculate, and they showed me that the sale would net twenty thousand reais. I asked them if that would be enough to buy a house in Rio. They said yes.

I told them to invite all my cousins to a goodbye party. They all came. We played my favourite songs, and I danced with my aunties and uncles, and played badminton with cousins. I had pancakes with ice cream. They all kissed me, even the ones who couldn't remember my name, and then they all went away.

You really want to go? said the house.

I said. *You're just a part of Them. They'll still be there on the other side.*

I can remember when we first got you. You were so small and sweet and you couldn't even walk. Now look at you, all grown.

Can I be a Daddy? I asked.

The house sighed. *No,* it said. *We had you fixed, I'm afraid. It's a small world.*

I remembered how Daddy always seemed bigger and smarter and older than everybody else, my mother too, and I thought: I wonder how much of a mistake it was, killing my Daddy.

I'm sorry, said the house *that you had such a sad 16th birthday. Next year will be better.*

The car came and took me to Rio. It was the right kind of car, the kind that bends in the middle and can go over the Edge.

But I asked it to stop. I got out and looked at the clouds and the mist, and the way even the clouds bent around the Edge, and I thought I could feel Daddy there, like the dust he had been made from, the dust they turned him into and how part of him might still be there floating like dandelion heads. That's all he would be now, light and dust, whirling back into the ground, and the ground would be broken apart and remade. They churn the dust into other things. Parts of my Daddy would rise up as a whirlwind of cars, or the top of the roads that built themselves, or in those solar panels, and maybe even just a tiny bit of him, in the black case of the television in my new house, so that when I asked to see him again, maybe just the tiniest little part of him really would be there.

Then I took a deep breath and stepped over the Edge, onto Rio, all by myself. I was a big boy now.

As big as they'll let me get.

To see the world of Belo Horizonte, visit
http://www.scalablecity.net/
Short movies are at:
http://www.scalablecity.net/trailer.html

ARTIST BIOGRAPHY
SHELDON BROWN

Sheldon Brown is an artist who works in new forms of culture that arise out of the developments of computing technology. He is Director of the Center for Research in Computing and the Arts (CRCA) at the University of California, San Diego (UCSD), where he is a Professor of Visual Arts and Artist-in-Residence at the California Institute for Telecommunications and Information Technology (Calit2).

The artist's work examines the relationships between mediated and physical experiences. This work often exists across a range of public realms. His work plays with overlapping and reconfiguring private and public spaces, with new forms of mediation, proliferating co-existing public realms with geographies and social organizations of increasing diversity. Brown's art explores the schismatic junctions of these zones – the edges of their coherency – providing glimpses into their formative structures with a view that suggests transformative modes of being and the extension of constrained boundaries.

Brown has shown his work at such places as The Museum of Contemporary Art in Shanghai, The Exploratorium in San Francisco, Ars Electronica in Linz Austria, The Kitchen in NYC, Zacheta Gallery in Warsaw, Centro Nacional in Mexico City, and others. He has been commissioned for public artworks in Seattle, San Francisco, San Diego and Mexico City, and has received grants from AT&T New Experiments in Art and Technology, the NEA, the Rockefeller Foundation, IBM, Intel, Sun, Vicon and others.

LEFT TO RIGHT - ALEX DRAGULESCU, JOEY HAMMER, ERIK HILL, MIKE CALOUD, SHELDON BROWN

ACKNOWLEDGMENTS

Scalable City is an ongoing art work that could only have been done with considerable support from students, staff, funding organizations and the institutions that have hosted various incarnations of Scalable City.

Graduate and undergraduate students who assisted Sheldon Brown, Director of the Experimental Game Lab, on various phases of the work have included: Erik Hill, Daniel Tracy, Kristen Kho, Robert Twomey, Christopher Head, Prakhar Jain, Alex Dragulescu, Carl Burton, Mike Caloud, and Joey Hammer, along with ongoing support from Todd Margolis, Carolyn Staggs and Helena Bristow.

Prior to the interactive installation on display in the gallery@calit2, Scalable City has appeared in different forms at major art institutions around the world. Initial displays of art work generated in the early days of the project were shown to the public at E3 2005 in Los Angeles, and at the Zacheta National Gallery in Warsaw, Poland. Scalable City then debuted as a full-fledged interactive work in 2006 at Ars Electronica in Linz, Austria. Subsequent installations included the Museum of Contemporary Art Shanghai in China, The Exploratorium in San Francisco, National Academy of Sciences in Washington, D.C., WAAG (Amsterdam), SIGGRAPH

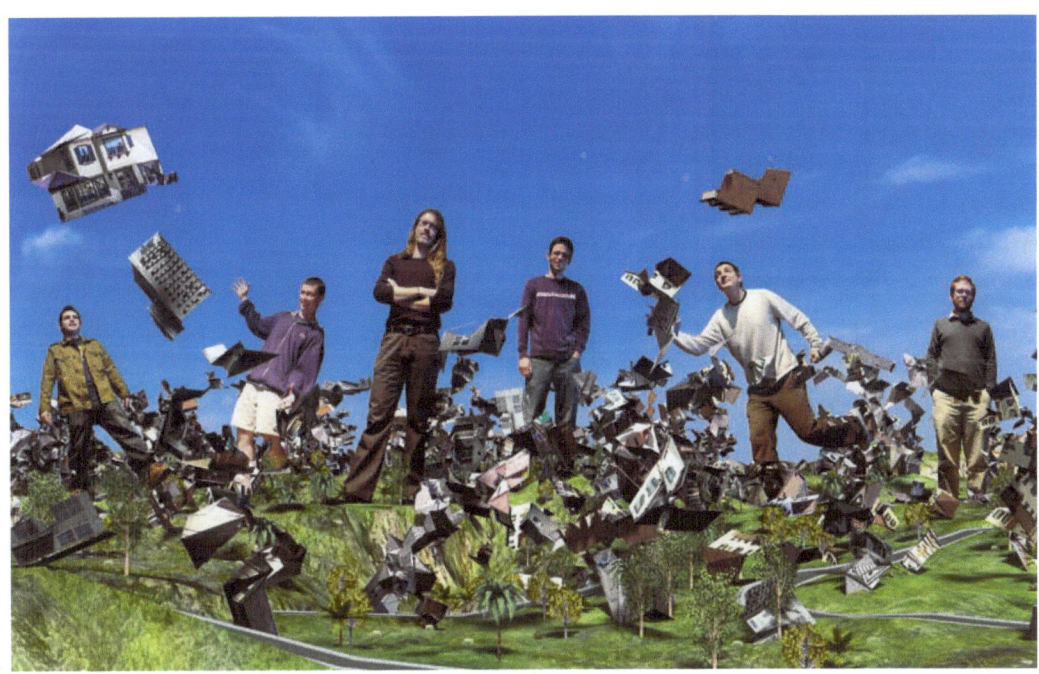

2007 (San Diego), SPLIT Festival (Croatia) and Supercomputing 2007 (Reno). So far in 2008, projected images for an urban environment were displayed for the Great Wall of Oakland project in Oakland, Calif., LA Freewaves, and a 4K video version of Scalable City (4K is four times the resolution of high-definition TV) made its debut at FILE 2008 in Sao Paulo, Brazil. In addition, parts of Scalable City have been demonstrated since 2005 for visitors to the Experimental Game Lab in Atkinson Hall, the headquarters of both CRCA and Calit2 on the UC San Diego campus, so the show installed in the gallery@calit2 is a coming-home of sorts.

Indeed, Scalable City is a work in progress by its very nature, and future incarnations are already on the drawing board for international as well as domestic venues, including the LA Bansdall Municipal Art Gallery, the Beall Center for Art and Technology, and Epcot Center. An online version is in development with Peking University.

Support for development of Scalable City comes from IBM, Intel, Sun Microsystems, Vicon, High Moon Studios, Red Bull, the UC Discovery Grant program, UCSD's Center for Research in Computing and the Arts (CRCA) and the UCSD division of the California Institute for Telecommunications and Information Technology (Calit2). Thanks to Jim Shea for helping nurture many of these relationships.

Finally, thanks go to colleagues involved in mounting the exhibit in the gallery@calit2, including former and current Gallery Coordinators Eduardo Navas and Trish Stone, respectively; Nicole Lascu and Cristian Horta for the layout of this publication and other collateral materials; Doug Ramsey for oversight of publications; and members of the committee overseeing the gallery@calit2.

gallery@calit2 reflects the nexus of innovation implicit in Calit2's vision, and aims to advance our understanding and appreciation of the dynamic interplay among art, science and technology.

First Floor
Atkinson Hall
9500 Gilman Drive
University of California, San Diego
La Jolla, CA 92093

http://gallery.calit2.net

Scalable City - Print #1 >

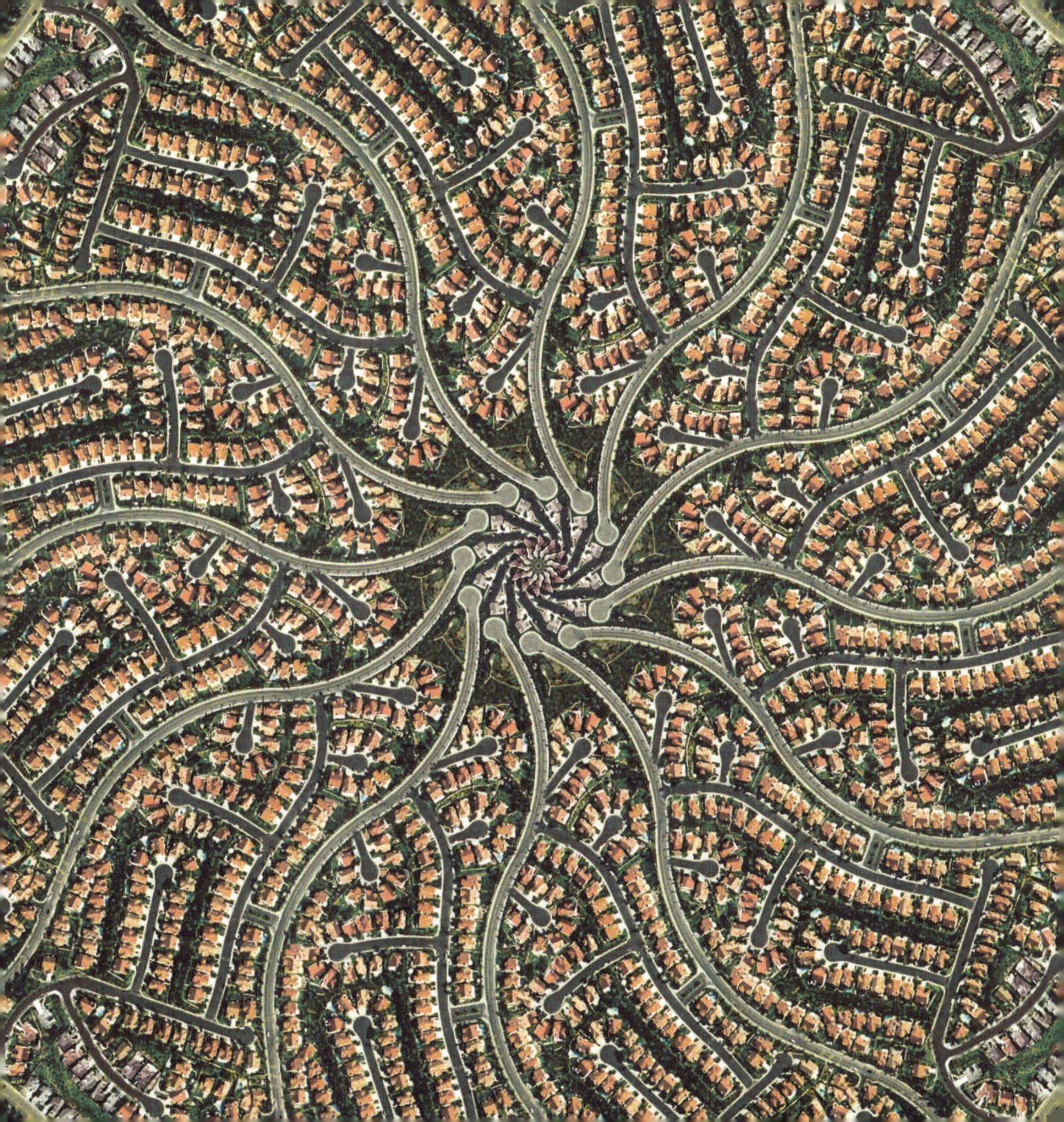

www.ingramcontent.com/pod-product-compliance
Lightning Source LLC
Chambersburg PA
CBHW050942200526
45172CB00020B/497